Anchorage
Early Photographs of the Great Land

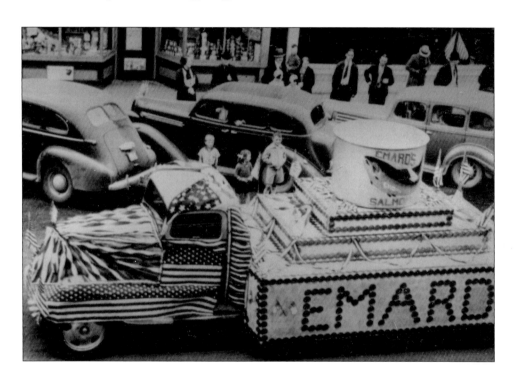

Ann Chandonnet

Front Cover Photograph: The 40-foot vertical pillar of the Art Deco-style Fourth Avenue Theatre is one of Anchorage's instantly recognizable landmarks.

Title Page Photograph: The Emard Cannnery showcased a can of salmon on its Fourth of July parade float. The cannery was located near the mouth of Ship Creek. c. 1930.

Canadian Cataloguing in Publication Data
Chandonnet, Ann-
Anchorage,
Early Photographs of the Great Land.

Includes index.
ISBN 0-9681955-6-3

1. Anchorage (Alaska)--Pictorial works. 2. Anchorage (Alaska)--History--Pictorial works. I. Title.

F914.A5C48 2000
979.8'35'00222
C00-900209-X

Digital Pre-Press by
 Joel Edgecombe
Edited by Clélie Rich,
 Rich Words Editing
 Services, Vancouver, BC
Design and Production by
 Wolf Creek Books Inc.
Printed and Bound in
 Canada by Friesen
 Printers, Altona, Manitoba

**WOLF CREEK
BOOKS INC**
Box 31275,
211 Main Street,
Whitehorse, Yukon
Y1A 5P7
info@wolfcreek.ca
www.wolfcreek.ca

Acknowledgements
 I owe much to M. Diane Brenner of the Anchorage Museum of History and Arts' photo archives for her help in finding many of the photos in the following pages. She and her staff are endlessly knowledgeable and cordial to researchers.
 The quote on page 112 by Alison Hoagland comes from "Buildings of Alaska," Oxford University Press. The quotes from Nellie Brown originally appeared in a June, 1957 issue of the *Anchorage Daily News*. The quotes on page 38 from Patsy Bowker James appeared in an interview in the *Anchorage Daily News* in 1981.
 Thanks to Gib Whitehead for the loan of photos from his private early Anchorage collection.
 Thanks to Robert Gottstein for taking a family photo right off his wall and allowing me to carry it off and copy it.
 The story "How the Chugach People Got Their Name" on page 11 is reprinted with the permission of John F.C. Johnson, copyright 1999; all rights reserved.
 The quote on page 13 comes from "On the Trail of Eklutna," copyright 1985 by Ann Chandonnet.

CONTENTS

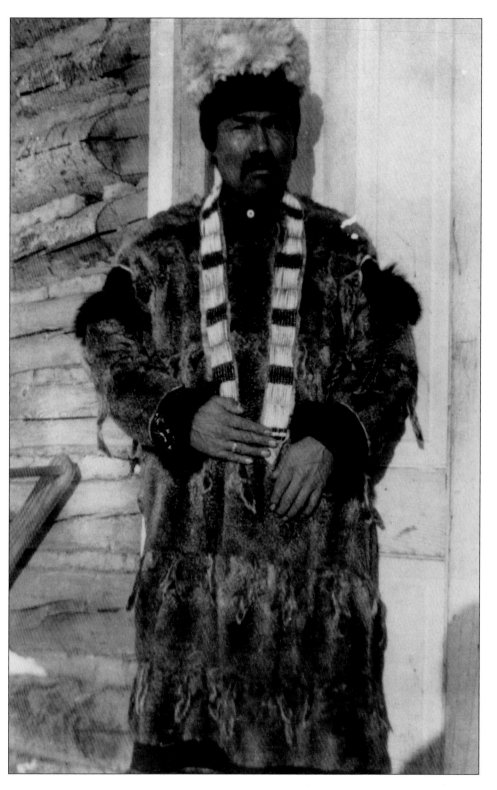

CHUGACH ESKIMOS AND TANAINA ATHABASCANS

The area along the eastern shores of the Knik Arm of Alaska's Cook Inlet is today known as Anchorage. But only a century ago, it bore dozens of names—Indian names.

Point Woronzof was Nuchíishtunt, or "Place Protected from Wind," a fish camp site where Tanaina Athabascan Indians from the villages at Knik, Susitna and Matanuska came to "make food" during the summer. From a log-dipping platform, salmon were netted. The salmon were then dried or smoked.

Lake Spenard and Lake Hood, interconnected waterways that today comprise one of the world's busiest seaplane bases, were Nilkidalíiy, "The Ones That Are Joined Together." Campbell Point, where a prehistoric battle took place, was Ulchena Bada Huchíilyut, "Where We Pulled Up the Alutiiqs' [Boats]."

The history of early peoples in the Anchorage area took wing 10,000 years ago, as glaciers retreated and the climate grew warmer and wetter. Caribou, mountain goats and Dall sheep were plentiful during this period.

Beluga Point, 17 miles south of Anchorage, offered early visitors a sheltered beach as well as a direct route for scrambles into the Chugach range. Artifacts left here from 10,000 to 8,000 years ago derive from the American Paleo-Arctic tool tradition; projectile points excavated here are identical with those from interior Alaskan archaeological sites of the same age.

About 8,000 years ago, the climate of Cook Inlet began to cool. Precipitation increased, vegetation changed, and moose and snowshoe hare became more plentiful. Caribou began to move away.

Around 4,000 years ago, maritime people of Eskimo-Aleut stock visited Beluga Point. Their artifacts are typical of the Denbigh Flint Culture. These people seem to have come by water directly from Asia.

Chief Stephen of Knik in a fancy ground squirrel parka, posed on the front porch of Herning's Store. When not following a traditional Tanaina Athabascan subsistence lifestyle, Stephen did odd jobs for Herning, such as cutting wood and driving wagons of supplies to Hatcher Pass. Stephen is wearing a necklace of dentalia (shells) and trade beads, and a Yupik-style headdress probably obtained through trade. ca. 1905.

Around 2,500 years ago, new explorers investigated the region. This time they were Pacific Eskimos and arrived from the Bering Sea. They shouldered aside earlier visitors, and split into two groups that settled down here. One group was the Chugach Eskimo or Alutiiq of Prince William Sound. The other was the Unegkurmiut, who inhabited Kachemak Bay during the winter.

Cook Inlet offered a valuable combination of natural resources. It had access to marine mammals as well as forest animals, to salmon and belugas, to seaweeds as well as bark, firewood, roots, edible plants and berries. Early peoples often combined these resources in dishes such as whale blubber with cranberries.

Naturally such a rich place attracted others. About 1,000 years ago, the Eskimos about Cook Inlet were evicted by a new group, Athabascan Indians from the Interior—specifically from Lake Clark and Stony River. In about 1650, Athabascans made Eklutna one of their winter villages.

The Alutiiq still coveted Cook Inlet's resources, and until 1914 made periodic raids from Prince William Sound over Burns Glacier and Portage Glacier. The Athabascans became a specialized tribe, adopting the maritime technology necessary to harvest the sea while keeping many subsistence traditions rooted in Interior forests. They became a unique people—the Tanaina or Denaina.

When the Russian Glottov traded with the Koniags at Kodiak in 1762, a boy told him that the people often traded with "the Aglegnutes [Aglegmiut Eskimos] of Aliaska Peninsula and with the Tanaianas of the Kenai Peninsula." This is the earliest reference to the Tanaina.

Inter-tribal trade continued until about 1900. For example, sea-going Aleuts came to barter. The Ahtna Athabascans walked from the Copper River region every summer to maintain trading relationships. The Tanaina traded with the Ahtna for luxury items such as copper arrowheads, cedar arrow shafts and animal skins. (One proof of this trade is a small fragment of copper dropped at Beluga Point about 700 years ago.) In addition to conducting trade, rival populations fought, kept each other as slaves and sometimes intermarried.

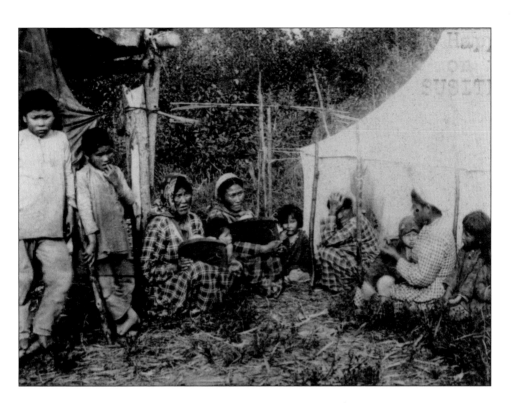

Above: A Tanaina fish camp on the Susitna River. Two women at center hold their babies in birch bark cradles similar to modern child car rests. ca. 1898.

The Tanaina spent the harsh winter months in sheltered villages, composed of nichil or barabaras—warm, semi-subterranean dwellings roofed with bark and sod. Winter was a time for hunkering down, tending the fire, telling long stories of legendary heroes and trickster Raven. During the rest of the year the Tanaina were semi-nomadic, following a cycle geared to particular resources. The seasonal cycle included muskrat camp, fish camp, berry camp, and caribou camp. The resources they used covered an area the size of Rhode Island. A clever people, they could fold and lash birch bark into everything from splints for broken limbs to baby cradles, from moose whistles to berry baskets. Their clothing of flannel-soft moose or caribou skin, decorated with porcupine quills, fringe and seeds, was prized by everyone who saw it.

They were prodigious travelers with a huge network of trails. Snowshoes (an Athabascan invention) enabled them to travel during months of deep snow. And they moved by water; an early explorer described their birch

bark canoes as moving on the surface of the Susitna as lightly as "dry leaves."

In June, 1778, British explorer Captain James Cook sailed into the area. He and his crew became the first Europeans to explore the great inlet. He named the eastern arm "Turnagain," and noted its "prodigious tides." Brave Tanaina from Point Possession (on the south side of Turnagain Arm) paddled out to Cook's ships in one-man canoes. At this point of contact, the Tanaina population was estimated at 5,000.

When Russian navigator Potop Zaikov encountered the Tanaina in August 1783, he described them as "of medium height, and have black eyes and hair. Their clothes are made mostly out of goose, deer and bear skins. They cut their hair just above the eyes in front and some have it tied behind and some wear it short." Zaikov traded steel needles and blue glass beads for sea otter skins.

In 1836, a smallpox epidemic broke out in the Russian capital of Sitka, and spread north. By the time the epidemic had run its course in 1840, half the Tanaina were dead. By 1860, the population had dropped to about 1,500.

In 1875, the Alaska Commercial Company (the successor to the Russian-American Company) established a fur trading post at Tyonek. The desire for guns and manufactured goods now began to permanently change the subsistence lifestyle of the Tanaina, as did American canneries, fish traps, saw mills and a handful of gold rushes. Some Tanaina consciously melted back into the forest; they moved away from the fertile shore to escape the onslaught of new influences, but white trappers soon caught up. The traditional Tanaina culture was further challenged by the Spanish flu epidemic of 1918.

Several Tanaina villages remain, Eklutna and Tyonek among them.

Opposite: A watercolor of a "Man of Turnagain River" by shipboard artist John Webber, executed May-June, 1778, during Cook's voyage to the Anchorage area. This is a Tanaina Athabascan wearing an elaborate tunic of skins with pendant feathers hanging vertically from a yoke across the chest. His forehead is painted red. There is a curved bone ornament through his nose, and extensions of plaited braids are fastened to his own hair. His lower lip has been perforated and holds three beaded pendants. The beads would have come from indirect trade with Russians.

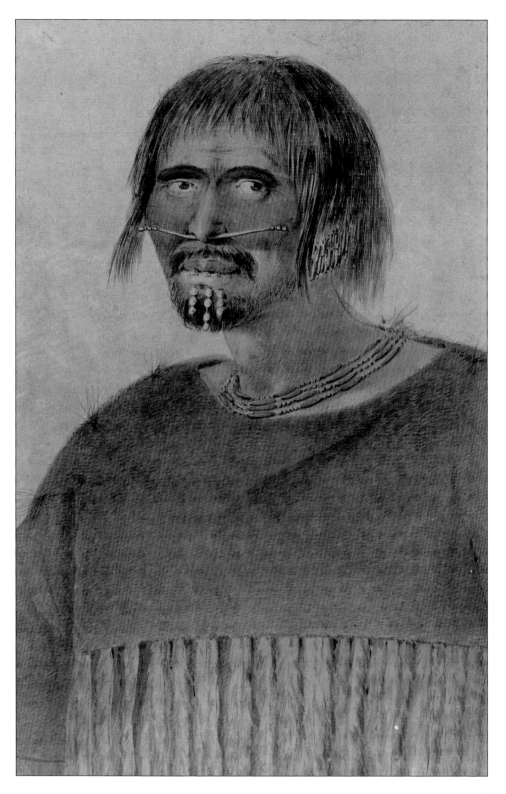

9

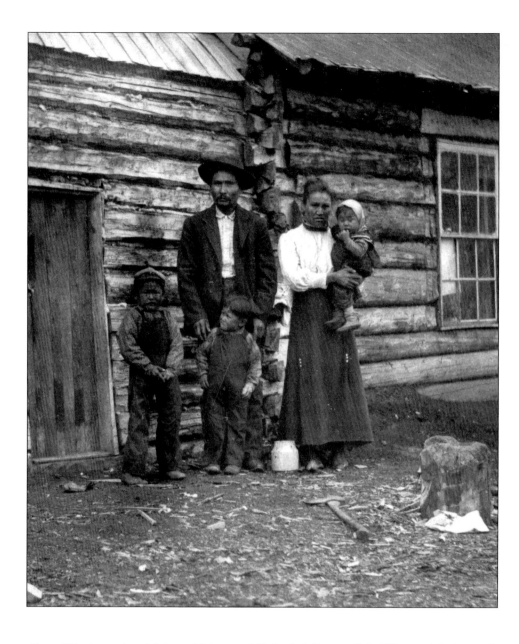

Above: A Tanaina couple and their three children—all in Western dress—pose before their log house. Glass windows indicate a homeowner of substance—a man with good trading connections. The above-ground log cabin was a style of dwelling introduced by the Russians, and is not the prehistoric semi-subterranean dwelling of the

Athabascans of Alaska. Probably Knik, c. 1900.

Opposite: A view of Old Tyonek, a Tanaina village on the west shore of Cook Inlet. c. 1898. Because of flooding in the 1930s, this low-lying beach site was abandoned and the village was moved to a location on higher ground. Tyonek,

Knik, Eklutna and Susitna people traded with one another as well as villages further afield.

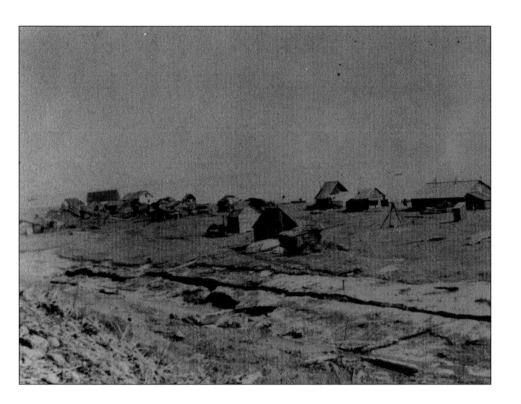

How the Chugach People Got Their Name

For ages and ages, Prince William Sound, as it was named by Capt. James Cook, was covered by a solid sheet of glacial ice that extended over nearly all of the bays and mountains. One day Native hunters came into the waters, kayaking along the outer shores of the Pacific Ocean. Suddenly one man cried out: "Chu-ga, chu-ga (hurry, hurry). Let's go see what that black thing is sticking out of the ice." ...So the hunters paddled closer and closer to see what the strange, shiny object was. Within a short distance, the hunters could see mountain tops poking out of the retreating ice... The ocean travelers settled along the sound's newly ice-free shores... As the seasons changed from year to year, the ice melted rapidly, exposing deep fiords and lagoons that were rich in sea life and provided good beaches to settle on. Animals thrived in the areas where the fresh and salt waters met... When the ice retreated, so did the animals. The Chugach people followed the ice and animals deep into the heart of Prince William Sound, what we call southcentral Alaska, where they remain today.

> *Courtesy John F.C. Johnson. The legend was passed down to Johnson by the late John Kalashnikoff, an Alutiiq elder born in the village of Nuchek in Prince William Sound in 1906. Kalashnikoff served for many years as harbormaster of Cordova.*
>
> *The legendary sighting of mountain tops probably dates to the collapse of the glacial ice sheet over Prince William Sound and its rapid retreat—prehistoric events which occurred more than 10,000 years ago.*

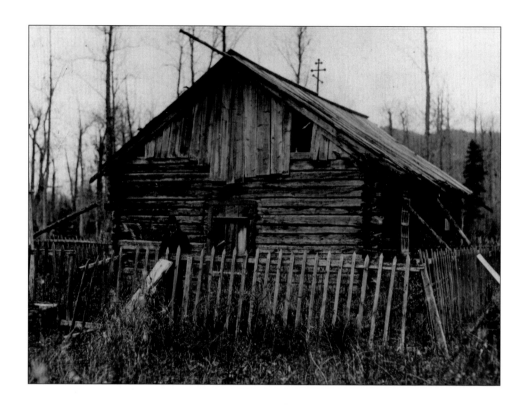

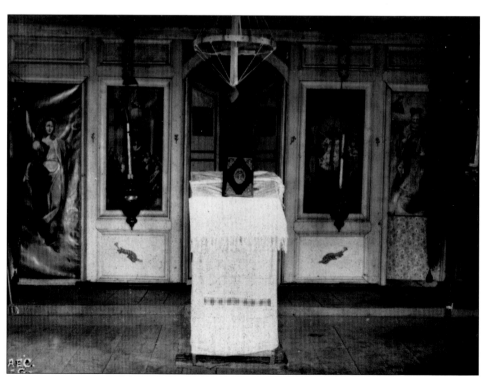

Opposite Top and Bottom: The Saint Nicholas Russian Church at Eklutna (c. 1870) is a simple, 19 x 30 - foot log structure. The interior is laid out in traditional Orthodox fashion, with a sanctuary behind a screen covered with icons. The rustic candelabra recycles rifle shell casings as candle holders. The man standing in the yard is probably Father Paul Shadura, the Parish Priest. This church was in use until 1962 as a place of worship. October 12, 1918.

Above: Tanaina elder Mike Alex (1907-1977), self-appointed caretaker of the St. Nicholas Church at Eklutna for 22 years. Alex worked for the ARR for 28 years. c. 1970.

Half of Alaska's Native people are estimated to have died during the Spanish flu outbreak of 1918. Mike Alex (1907-1977) survived. As a child, he followed a typical semi-nomadic existence of those days. Mike said, "We lived off the country; today you have to have a license for fishing, a license for the boat, a license for trapping. No such thing then. When we cooked roast over the fire on a sharpened stick, we would put a piece of birch bark underneath to catch the drippings. We used to eat beluga oil, fish, (Dall) sheep. Today everyone runs to the store."

"On the Trail of Eklutna."

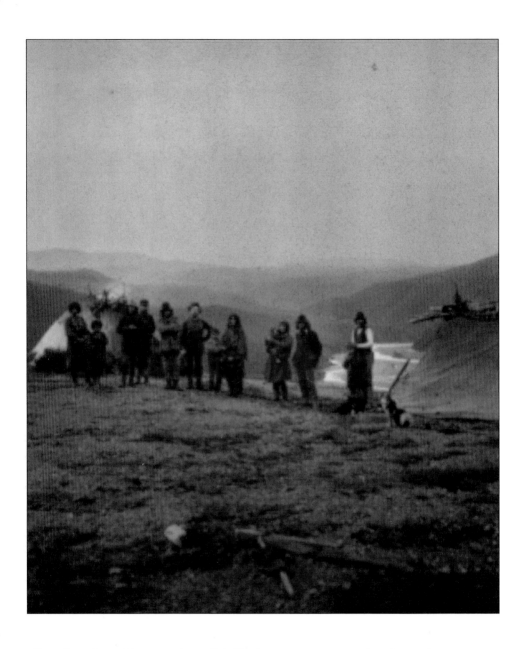

Above: Upper Copper River Indians, also known as the Ahtna or Ahtena. Summer Camp. The Ahtna regularly walked 100 miles down the Matanuska Valley to trade at Knik, Eklutna and other sites with the Tanaina. Some intermarriages among the two peoples resulted from these trading visits. The Ahtna were also known to raid the Tanaina on occasion. Valuables, food and wives were the usual reason for raids. 1898.

Opposite Top: "Nakeeta, wife and boy" (left), "John Evan and wife" (right). Two large black dogs are in the foreground. Evan wears moccasins with floral beading on the vamps. The man at the left is perhaps the same important Tanaina man Orville Herning recorded in his diary about 1900 as "Nikita, or Big Nikita, or Nakeeta, or Nekeeta." Photo taken near Knik, 1906-08.

Opposite Bottom: Log cabins and caches, probably Knik. c. 1900.

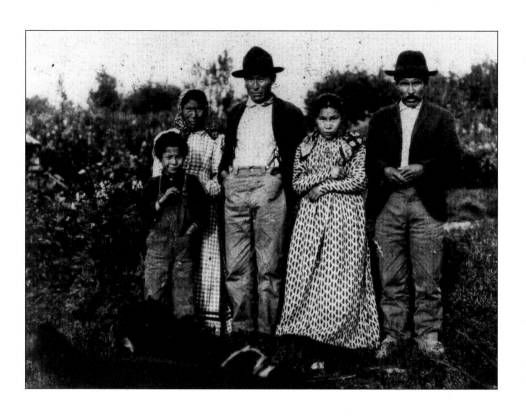

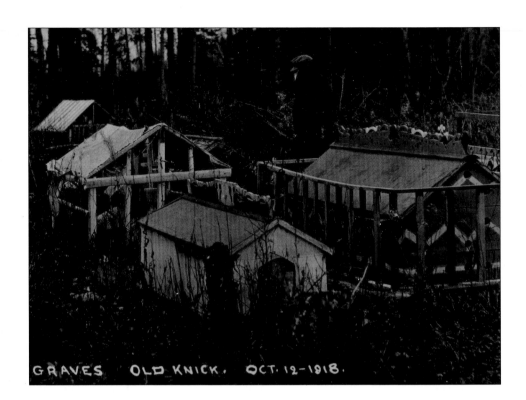

GRAVES OLD KNICK. OCT. 12-1918.

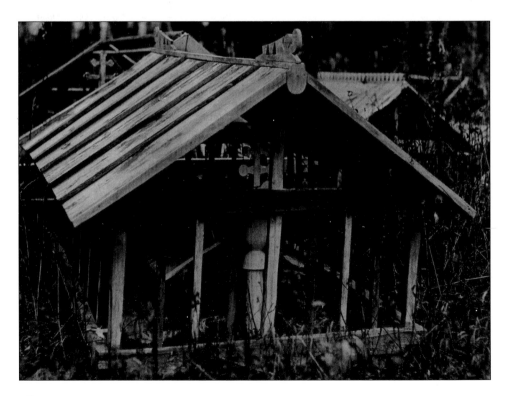

Opposite Top: Traditional Indian grave markers are known as "spirit houses." Favorite possessions of the deceased, such as a teacup or doll, were deposited under these roofs. Personal effects left at one grave include a greatcoat and hat on a stand (right background).

Opposite Bottom: Closeup of a grave at Eklutna, October 12, 1918. A smaller, older, house-like marker and an Orthodox cross can be glimpsed within the larger monument. The picturesque cemetary faces the St. Nicholas Russian Church, and attracts thousands of visitors every year.

Above: Rectangular depressions called house pits indicate the former site of Tanaina winter dwellings. These dwellings were built over three-foot-deep holes, heated by a central hearth.

Before white contact, the Tanaina cremated their dead. Abbot Nicholas, the first Orthodox missionary assigned to the Kenai parish, tried to persuade them to give up this practice. He wrote in his diary for June 22, 1859, "They burn their dead because, as they say, the relatives are ashamed to leave the bodies for worms. I have advised them to discard this custom, but did not insist...."

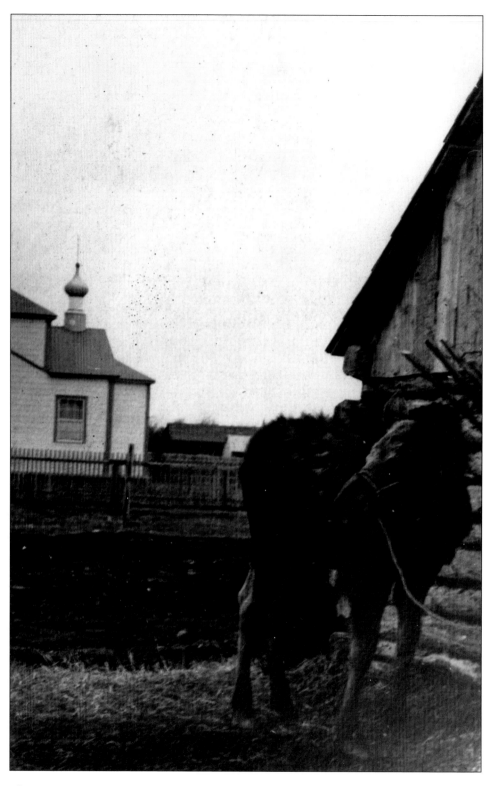

EXPLORERS AND RUSSIANS IN COOK INLET

The first recorded visit by Europeans to the trackless vastness of Alaska occurred in 1741 when Danish navigator Vitus Bering sighted the coast near Cordova while flying the flag of the Russian Czar, Peter I. Sea otter pelts brought back from this voyage caused a sensation when they were exhibited in Petropavlovsk and started a "fur rush."

Country after country sent explorers. Many ventured no further north than Tlingit territory in Southeast Alaska. But Davydov, Lisiansky, Portlock, Dixon and Meares all visited Cook Inlet.

One of the best known explorations of what was to become the Anchorage area was made by Captain James Cook in 1778, when Cook's two ships entered what the captain hoped would be the long-sought Northwest Passage. Between May 26 and June 6, Cook and his men explored and mapped the Inlet. Tanaina from the Kustatan or Tyonek areas approached the ships in kayaks on May 30. On May 31, near Tyonek or North Foreland, a large group of men, women and children approached Cook's ships in an umiak (large skin boat) and several smaller kayaks, displaying a garment on a pole—a sign of friendship. They then boarded the ships. The British still had not ventured ashore. But on June 1, the ships anchored off Point Possession, and a party led by Lt. James King went ashore, where the inhabitants gave them a porcupine and a caribou. A guard dog bit the ship's surgeon; in a display of firepower, Cook's men shot the dog.

Church of the Assumption of the Virgin Mary at Kenai, with moose tethered in foreground of plowed garden plot. Kenai was the headquarters of an Orthodox parish founded in 1849 that included the entire Cook Inlet area. The parish was so large that it often took two years for the priest to visit all of it. The Orthodox priest who served Kenai from 1896 to 1906 was Ioann (John) Bortnovsky, succeeded in 1908 by Paul Shadura, who served into the 1950s. Building of this church began in 1894. It was dedicated on June 8, 1896, by Heriomonk Anatoly. Photo probably before 1910.

With about 40 Tanaina as witnesses, the explorers displayed the British flag and buried a bottle containing two coins and a proclamation of ownership. Historian Hubert Bancroft wrote of this exchange, "Some lords aboriginal were present, but it is nowhere written that King asked their permission to take possession of the country, as the admiralty had ordered."

To clinch Cook's success, Britain sent Captain George Vancouver back to South Central Alaska to make more detailed charts and name important geographic features. Vancouver encountered Russian settlers in the Anchorage area. They had no agriculture, but chose to "live after the manner of the native Indians," Vancouver commented.

Shell middens (some 15 feet deep), the rectangular depressions called house pits that indicate the remains of Tanaina winter homes, fire-cracked rocks used in steam baths, thousands of pits in which fish were cached, rock paintings, rock shelters and occasional artifacts all reveal the prehistoric residents of the area. A semi-nomadic people lacks the leisure to construct huge stone temples or carve totem poles, making it difficult to trace the prehistory of these ingenious early residents.

When the Russian period of settlement began, however, it left remnants that were easier to find. Perhaps the most photogenic evidence of Russian-Tanaina history remains in various Russian Orthodox buildings, such as the Holy Transfiguration of Our Lord Church at Ninilchik (1901), the St. Nicholas Church at Seldovia (1891), the Saints Sergius and Herman of Valaam Church at Nanwalek (1890) and the Holy Assumption of the Virgin Mary Orthodox Church at Kenai (1895).

Russian fur traders initially concentrated their efforts in the Aleutians. No permanent settlements were made on the Alaska mainland until 1785-86 when Grigorii Shelikov ordered a fortified settlement called Alexandrovsk Redoubt (or Fort Alexander) to be built at Nanwalek (formerly English Bay) on the Kenai Peninsula. Shelikov was anxious to find new sea otter hunting grounds, and entrusted K.A. Samoilov with administering a string of settlements or trading posts in the Kenai and Chugach regions.

The second Russian trading post established in the area was Fort St. Nicholas (Nikolaevsky Redoubt), under the command of Gregory Konovalov. It was established on the sandy 100-foot bluff at the modern site of Kenai in 1791. When Vancouver came ashore at Kenai in 1794, he found about 40 Russians occupying the outpost, living in conditions he considered squalid.

Opposite Top: "St. Nicholas Inlet, Alaska." An engraving from the early 1800s shows a typical Russian outpost in Alaska.

Opposite Bottom: Boats of the Klondike and Boston expedition on a tributary of the Susitna River, 1898. Prospectors used shallow draft boats to access the Interior. The Susitna is navigable by flat-bottomed vessels, canoes and barges from its mouth to its confluence with the Talkeetna River 75 miles upstream.

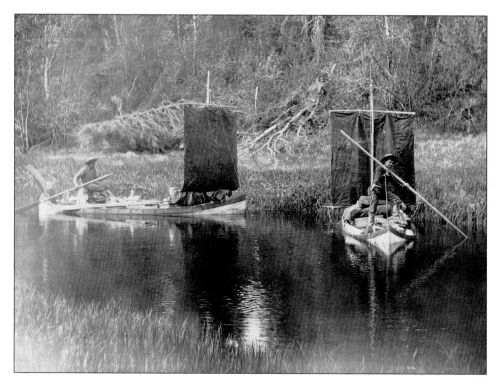

Relations between the Tanaina and the Russians were often stormy. In a 1793 letter, Aleksandr Baranov describes a fierce battle following a night attack on his camp on Nuchek Island in Prince William Sound by armored Tlingits and Ugialiagmiuts. In another letter from Baranov, written from Kodiak on April 28, 1798, he notes more incidents: "The Kinai [Tanaina] people arose because of their [traders'] cruelties and wiped out their two artels [traders' outposts] on Kodiak and Iliamna, killing twenty-one Russians." In a letter written from Nuchek in May, 1880, Baranov is still harping on the "savage adventurous spirit of the Chugach, Copper River natives and Ugialiagmiuts."

Russian American Company records speak of cruelties—of beating and crippling Kenaitze (the area's Athabascan Indians) who will not hunt for them, of taking their children as hostages, and not allowing parents to visit their children.

The Russians had so little knowledge of the Cook Inlet area that they did not even try to establish an Orthodox parish here until 1846—approximately 11 years after the village of Ninilchik was settled by aging Russian American Company employees and their Athabascan wives. The new Kenai Parish covered the entire area occupied by the Tanaina, all around the shores of Cook Inlet.

In 1846, Egumen (Abbot) Nicolai was assigned to Kenai. Nicolai was the first resident priest; his assignment was to provide spiritual leadership to resident Russians and to convert the Kenaitze. The parish was so big, however, that missionaries typically required two years to make a complete circuit of all its villages. When the missionaries arrived, they would "catch up" by baptizing all children who had been born since their last visit, and marrying all new couples. For holding services where churches had not yet been erected, the early Orthodox missionaries used what they called "a traveling church"—a canvas tent that they could fold and transport in a wheelbarrow or by baidarka.

Support for Orthodox parishes declined after the sale of Russian Alaska to the United States for $7.2 million in 1867, and declined even further after the Russian Revolution of 1917.

Opposite: On the heels of explorers came tourists like H.M. Wetherbee of San Francisco, who made four voyages to Cook Inlet between 1889 and 1892. He is modeling a Tanaina summer shirt decorated with porcupine quills and fringe. Wetherbee titled this self-portrait "Wild and Wooly in High Latitudes."

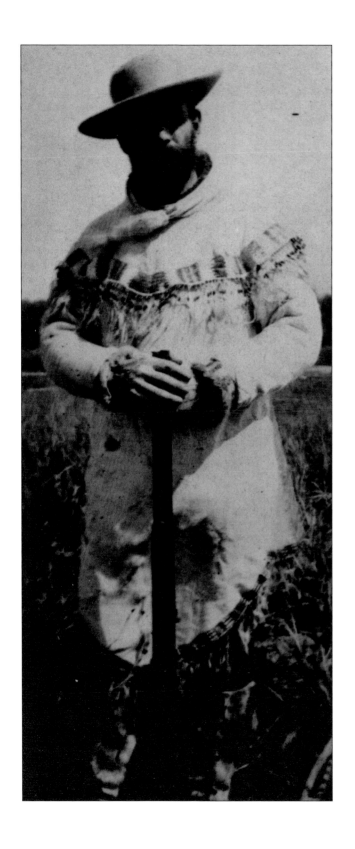

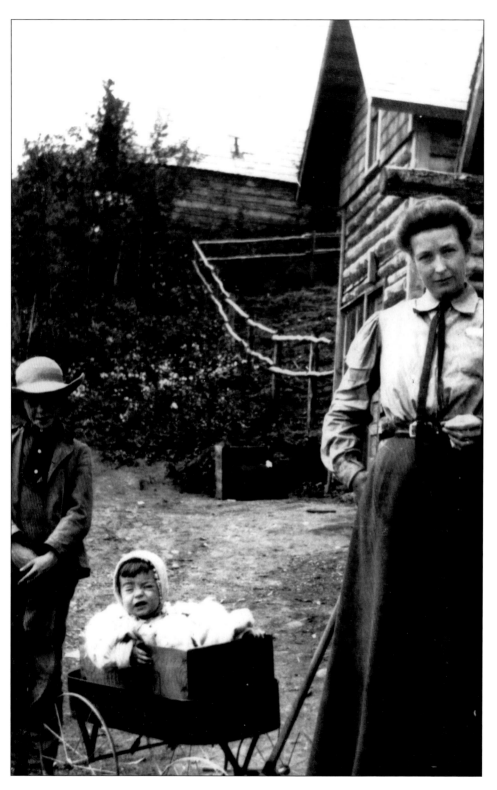

KNIK AND WASILLA

In the not-so-distant past, both Knik and Wasilla were Tanaina Athabascan settlements.

The culture of the area that was to become Anchorage began to change as newcomers and explorers passed through. In 1898, for example, Walter Mendenhall, Captain Edwin F. Glenn's geologist, crossed Crow Pass (above modern Alyeska Resort) to reach Knik. Today known as the "Crow Pass Traverse," the route involves skirting a glacier and fording glacial streams. Mendenhall estimated there were only 100 Matanuska Athabascans alive at that time.

Also in 1898, three thousand prospectors flooded into Cook Inlet. Among them was the Klondike-Boston Expedition No. 4, a group of 10 including Orville Herning. They landed their provisions at Tyonek, hired a Tanaina guide, made a map of the area and explored the Susitna River as far as Willow Creek.

In this same busy year, Josiah E. Spurr and his companions, employees of the U.S. Geological Survey, explored north from Susitna Station. They dragged three birch bark canoes over the Alaska Range, fighting the discomforts of rapids, mosquitoes and wet clothing in their search for the upper reaches of the Kuskokwim. They were befriended by Chief Nicholai and eventually made their way to Bethel.

In 1899, the U.S. government sent an expedition in search of a practical overland route from Cook Inlet to the Yukon. The party, led by Lt. Joseph Herron, included 15 horses—seen by the Athabascans as a species of moose. The Herron party became hopelessly lost, and had to be rescued by Chief Sesui of Telida.

When the Klondike and Boston Development Company closed its mining operations in 1904, prospector Orville Herning became a merchant at Knik. Here Herning's wife Martha Herning and her children are in the yard of the Knik Trading Company. Elmer stands; Stanley sits in the wagon.

Few of the prospectors who entered Cook Inlet became rich. Most returned home in a year or so. But a handful, like Orville Herning, decided to settle down and become entrepreneurs. Herning built a house at Knik, hired local men such as Chief Stephen to do odd jobs, and sent for his wife and family. As the population increased, a post office was established at Knik in 1904.

As a storekeeper, Orville Herning needed customers. For 40 years, he played the indefatigable booster—taking photos and turning them into postcards, printing advertising leaflets describing "sunny Knik."

A small boom rattled the area when gold was discovered on Otter Creek (near Flat and Iditarod) on Christmas Day, 1908. The subsequent rush increased traffic in Cook Inlet. At the height of the boom, 2,000 people resided in the Iditarod area, with a tramway connecting the two towns. However, by 1919 the strike had played out.

In 1910, the population of Knik was 118—compared to a population at Kenai of 250. In 1911, Knik was assigned its first marshall, W.H. O'Connor. By 1914, Knik was the largest community on upper Cook Inlet, boasting its own four-page weekly, the *Knik News*, as well as two trading posts (one is Herning's Knik Trading Company, or "K.T. Co."), a general hardware store, three roadhouses and hotels, a restaurant, a saloon and a construction business. Two dentists and two physicians ministered to the needs of residents and prospectors from the Willow Creek mining district and beyond. Many prospectors spent the winter months living in Knik, residing on their claims only during the summer. Herning's diary records diversions for days when it was too cold to venture outside: "bake bread, sew up mitts and horse blankets, put new soles on moccasins or a fur lining in cap."

Surveyors for the Alaska Railroad bypassed Knik, because laying track to that townsite would require a loop. They planned a station a bit to the north, at an area near a lake known as Wasilla—in honor of the late Chief Vasillia or Wasilla (d. 1907). Herning immediately began building a two-story trading post opposite the train station, and transferred his base of operations here. He described this location in advertising flyers as "the McKinley Park Route at Wasilla."

As Anchorage blossomed, Knik faded. In May, 1916, the Knik post office was discontinued. On June 29, 1919, Herning sadly records in his diary, "Only McNeil, Blodgett, and Ellexsons left at Knik."

Opposite Top: Ladies' nail driving contest, July 4, 1914, Knik. The contest was held in front of George Palmer's trading post.

Opposite Bottom: Herning's store at Wasilla was a 23 x 75-foot frame building covered with corrugated metal. c. 1931. The building was donated to the Wasilla-Knik-Willow Creek Historical Society in 1987.

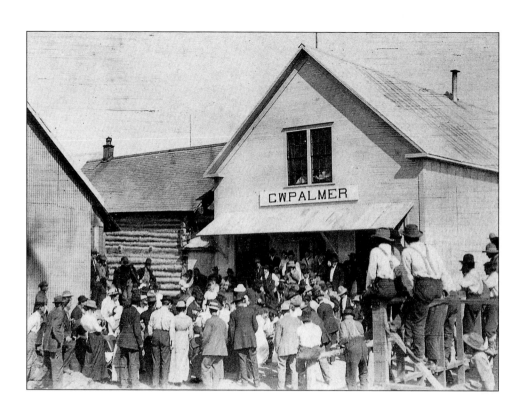

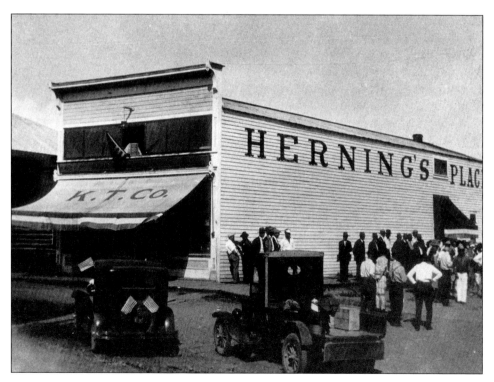

As soon as it was accessible by rail, Wasilla began to attract homesteaders in greater numbers. Gerrit "Heinie" Snider and his wife, Alice, homesteaded at Lake Lucille in Wasilla in 1920, and the couple began a fur farm. In 1929, the Sniders made a mink shipment worth $1,000—an occurrence sufficiently newsworthy that Herning left his front counter and crossed the road to the depot to take a photograph.

Development in the area remained light until February 19, 1934, when Don Irwin, superintendent of the U.S. Experiment Station at Matanuska, and A.A. Shonbeck, a valley landowner, were called to Washington, D.C. to discuss the possibility of an agricultural colony in the Matanuska Valley. The colony was approved on January 15, 1935. The following month, 80,000 acres of valley land were withdrawn from homesteading, to be reserved for the colony. Prior to the colony, 117 families were counted in the area, families who had cleared over 1,000 acres. Settlers included the Monaghans, Hoffmans, Kings, Clarks, Moores, Lamps and Brazils.

Now 202 new families came north. When the women and children from Michigan and Wisconsin arrived in May, 1935, they were welcomed with a luncheon in Anchorage. Fred Klouda Sr. was then nine years old, orphaned and living with his grandmother. This was the Great Depression, a hard time for many—a time of empty pockets, patched pants and rumbling stomachs. Klouda recalls the luncheon: "It was a big event. They came in on the train [from Seward]. They had what they used to call the old gymnasium uptown...built to make a movie about Alaska in the '20s. These people got off the train, and then they walked up the hill from the depot. The gym was all set up with tables for lunch, with food prepared by the local women. All the kids were down there watching all that fancy food. We couldn't stay away. Then the colonists got back on the train and went on to Palmer."

Today Knik and Wasilla flourish as bedroom communities for Anchorage workers.

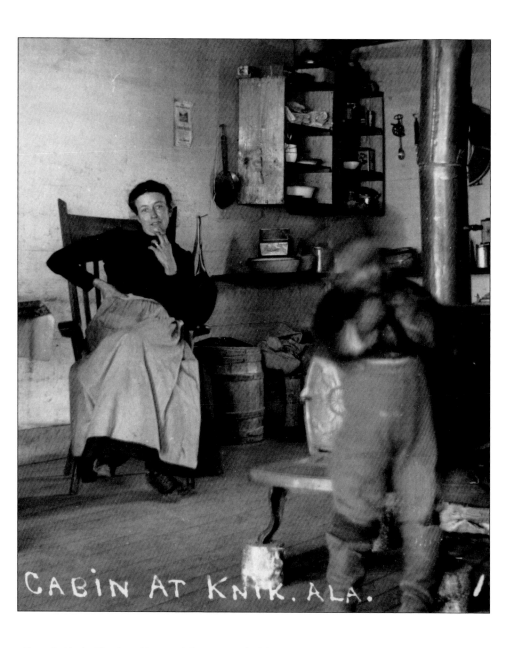

CABIN AT KNIK. ALA.

Above: Inside the Herning cabin at Knik. Mrs. Martha Herning and son, in motion, in front of the wood stove. The stove is raised off the floor on chunks of wood, so that when the legs are hot, they will not set the floor on fire. 1902.

This is wonderful country. There is enough gold here to load a steamboat…. Around some of the camps they have it piled up like farmers have their wheat.
Alaska and the Klondike Gold Fields, 1897.

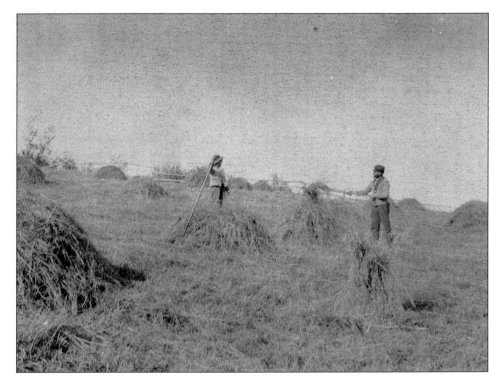

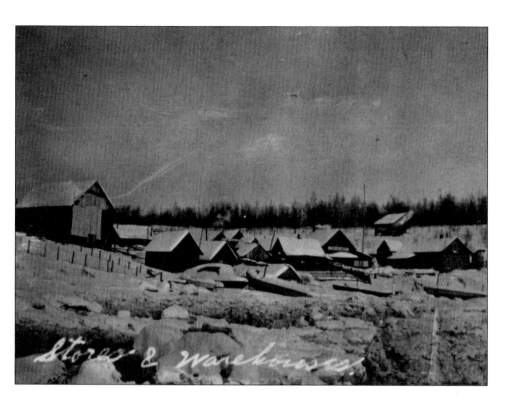

Opposite Top: The Pioneer Hotel's thriving potato field at Knik helped feed guests.

Opposite Bottom: Oat hay grown for pack animals, Knik, 1904. This is one of the first agricultural crops ever grown in the Anchorage area.

Above: A winter view of the town of Knik taken by resident O.W. Herning.

I still thought the Klondike was in Alaska, and I wanted to go there where I understood men were picking up gold in large chunks and carrying them away for a life of wealth, leisure and security.

Zachariah "Z.J." Loussac was born in Russia and educated as a pharmacist in New York City. He arrived in Nome in 1907, went broke, tried Haines, then Iditarod, a boomtown connected with Knik by the Iditarod Trail. In 1915 he set up his first drug store in Anchorage, in a tent. The pharmacy prospered and he made a fortune—half of which he put into a trust for his adopted home town. When Loussac set up the Loussac Foundation in October 1946, he said, "The people of Anchorage have been good to me. Everything that I earned came from here and I wanted it used here." Anchorage's first library blossomed from his gift, and the present headquarters library is named after this generous benefactor.

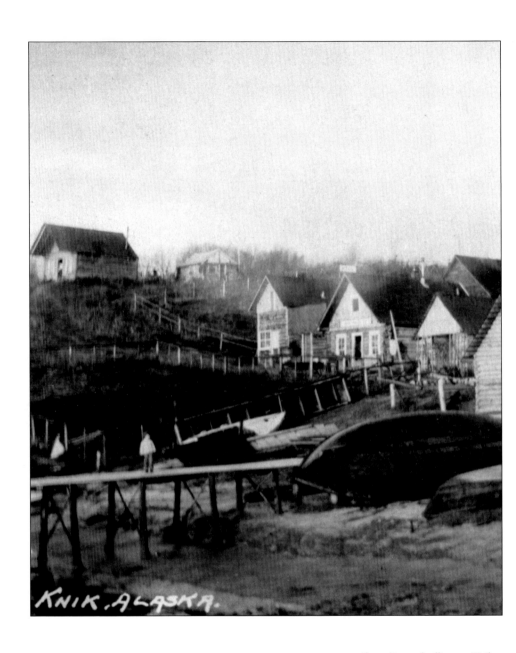

KNIK, ALASKA.

Recent arrivals from the Iditarod say the government party under Jack Dalton is making good progress in preparing to bring the coal from the Matanuska fields to the coast. They have the building for both men and horses finished at Knik and several points along the trail and expect to begin the work of transporting the coal in a few days. As a result of the operations, Knik is experiencing a period of prosperity such as has never before been enjoyed.

The Douglas Island News, December 31, 1913.

Above: Frame dwellings at Knik, with wharf in foreground at low tide. Herning's store is the structure with the two windows with white woodwork. The only building remaining at this site today is a restored pool hall, which is open as a museum. c. 1904.

Above: Waiting for the tide, Knik Arm, Alaska.

A salmon cannery will be putting up salmon next spring [at] Goose Bay and will employ at least 50 men. Goose Bay is about 8 miles below Knik and there August Bushman has secured a site and has already put men to work getting out timber and doing other preliminary work for the establishment of the cannery.

The Douglas Island News, November 18, 1914.

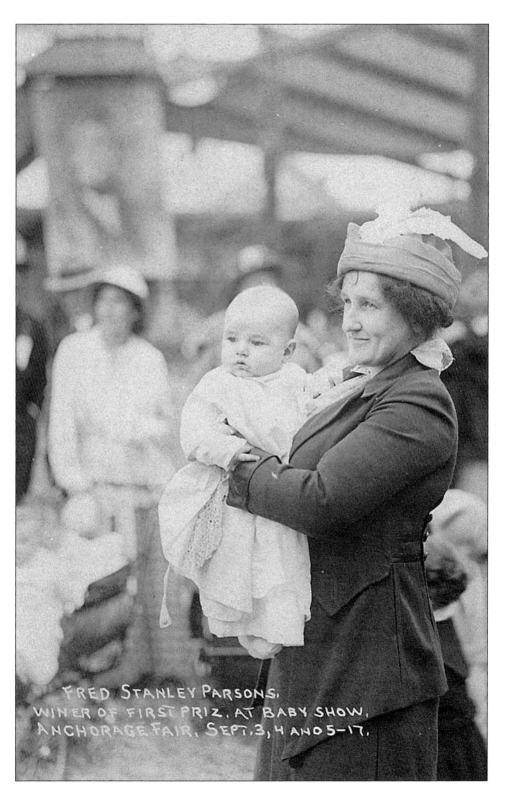

FRED STANLEY PARSONS,
WINER OF FIRST PRIZ. AT BABY SHOW,
ANCHORAGE FAIR, SEPT. 3, 4 AND 5-17.

OLD TOWN ANCHORAGE

The state of Alaska is nicknamed "the last frontier" because it is still a very new part of the United States. In October, 1867, as part of the Alaska Purchase, Russia surrendered its Cook Inlet holdings to a San Francisco-based group, the Alaska Commercial Company. But little happened until the late 1800s, when trading posts were erected at Tyonek, Susitna and the mouth of Knik River.

As late as 1913, for example, there was no Anchorage. There was a spot called Ship Creek in English, given its name because the clear, cold creek was deep enough for small ships to enter it. But only three couples (including Jack and Nellie Brown) and one bachelor resided in the area, which was a traditional summer fish camp site for the Tanaina Athabascan people—as evidenced by fish-drying racks near the shore. Ship Creek, an important stickleback fishing site for the Knik Tanaina, was Dgheyaytnu in the Tanaina dialect.

When forest ranger Jack Brown and his bride, Nellie, moved from Cordova, arriving on June 3, 1912, Ship Creek was a wilderness criss-crossed by moose and bear trails. Forty-five years later Nellie recalled, "Jack and I arrived aboard a little boat called the Alaska. Capt. Jim Ward was the skipper and Oscar Gill was engineer. Jack came to Anchorage in 1910 and surveyed the first homestead for J.D. Whitney, located seven miles up Ship Creek on what is now Fort Richardson. At that time there was nothing there but scrub timber. We called it Geepole Flats."

For Thanksgiving, 1913, the Browns and their neighbors roasted ptarmigan and wild geese.

Mrs. Parsons shows off her son, Fred Stanley Parsons, winner of first prize in the Baby Show, Anchorage Fair, September 1917.

"In 1914, a party of engineers arrived and started to survey the Alaska Railroad from here to Fairbanks. William C. Edes was the ranger," Nellie Brown recalled. "With him were Frederick Mears, B.H. Bandallar, R.D. Chase, Jack Dalton of the Dalton Trail...and between 50 and 75 other men. I was the only woman."

The mouth of the rushing creek offered a good place to off-load supplies. So this area became the mid-point construction headquarters for the government-owned railroad. Suddenly the quiet streambank and surrounding hills were abuzz with survey parties, staked-out pack animals, and the clamor of trees being felled and corrals built.

Building the actual railroad would require thousands of laborers. As Alaska Engineering Commission surveyors nervously rode their horses through the tall grass along Ship Creek, they kept a cautious lookout for brown bears. Soon the sound of tent pegs being hammered into damp ground filled the air. Shiploads of cross ties, rails, spikes and construction equipment followed. Prospects for a town looked so good that in 1914 Jack Brown quit the Forest Service and built his own boat, the *Progress*, which he used to haul passengers from the ships which anchored in Cook Inlet to Ship Creek and Point MacKenzie.

By June 1915, 32 blocks were cleared. Confirmation that there would definitely be a town here came on July 10 and 11, 1915, when 655 lots were auctioned off for a total of $148,000. The glowing oratory of auctioneer Andrew Christensen apparently spurred buyers to bid more than they had intended. Among those buying lots was Swedish-born Oscar Anderson, the town's first butcher and meat packer. Anderson bought a lot for his business, as well as a lot for the cozy residence he planned, Anchorage's first frame house. Della and Irving Kimball, who had run a store at the mining town of Latouche, also attended the spirited auction. The Kimballs bought lots at the corner of West Fifth Avenue and E Street and established a dry goods business. Their daughter Decema was still running the business in the same location in 1999.

Names proposed for the new town included Brownsville, Whitney, New Knik, Anchorage, Alaska City, Woodrow City, Lane, Matanuska and Gateway. Submitted by Ray McDonald, Anchorage won.

Nellie Brown recalled the days of the tent city: "We were all one big family in those days. We didn't lock our doors at night and the coffee pot was always ready

Opposite Top: Tents among freshly cut stumps, Anchorage, 1915.

Opposite Bottom: View of Tent City from a hill, 1915. The Chugach Range is on the horizon.

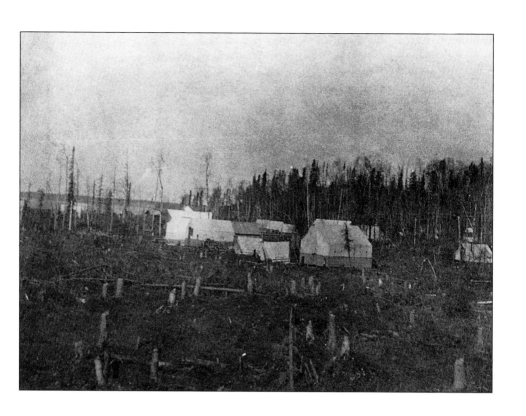

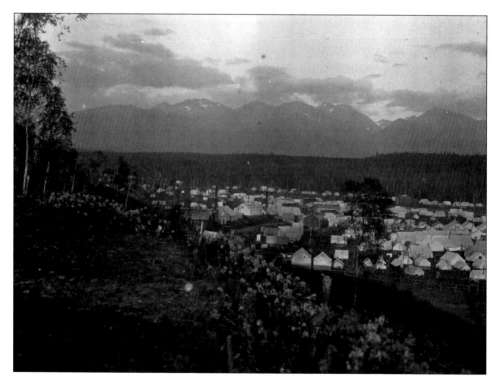

for everyone to help themselves. For greens, I cooked goose tongue, lamb's-quarter, fireweed and dandelions. For amusement, we played cards. Everyone went to bed at 9 p.m. in 1915."

The new town attracted many people who would later distinguish themselves in its history. Among those who settled here in 1915 were Zachariah Loussac, a Russian-born pharmacist. He had followed the gold stampede to Iditarod, but now gave up on prospecting and set up a drug store in a tent. Landscape painter Sydney Laurence also arrived and opened a photography studio.

In 1916, 12-foot concrete sidewalks were completed along Fourth Avenue, and the Empress Theatre was built. The Browns now considered Anchorage so crowded that they joined the Whitneys in home-steading near Green Lake on what is today Elmendorf Air Force Base.

By 1917, Anchorage had a population between 6,000 and 7,000, with about 4,000 permanent residents. It was the principal coal and freight terminal for Alaska, boasting a large hospital, a telephone/telegraph/electric office, a school, a Masonic temple, several churches, a YMCA and graded streets.

Anchorage was a pleasant place to grow up, says Patsy Bowker James, who was born here in 1920, when the population was 1,856. "It was a very nice little town, not rough at all. There was lots of law and order. We only had one policeman (in the '20s), so you can see how rough it was. If someone got into trouble, they gave him a blue ticket (a passage out of Alaska), so he'd go south and wouldn't come back. We had only one boat a week, and everybody went to the Post Office to visit. There were no telephones, so you had to rely on each other for fun."

Opposite Top: Some of Anchorage's first houses were not tents, but rude A-frames with sod roofs. Joe Curten and the builder of the first residence on Government Hill (on the north side of Ship Creek), 1915.

Opposite Bottom: A cabin in Anchorage where Providence Hospital was later located. The man at right is carrying a cat, a prized possession in boomtowns where vermin flourished.

Pages 40 and 41: "The White City," Anchorage July 1, 1915. The baseball field is at the right center, ready for the big game on the Fourth of July.

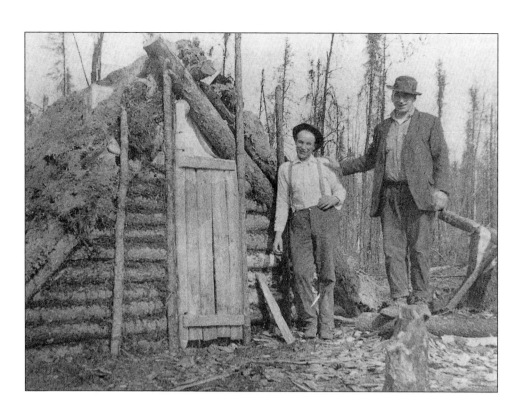

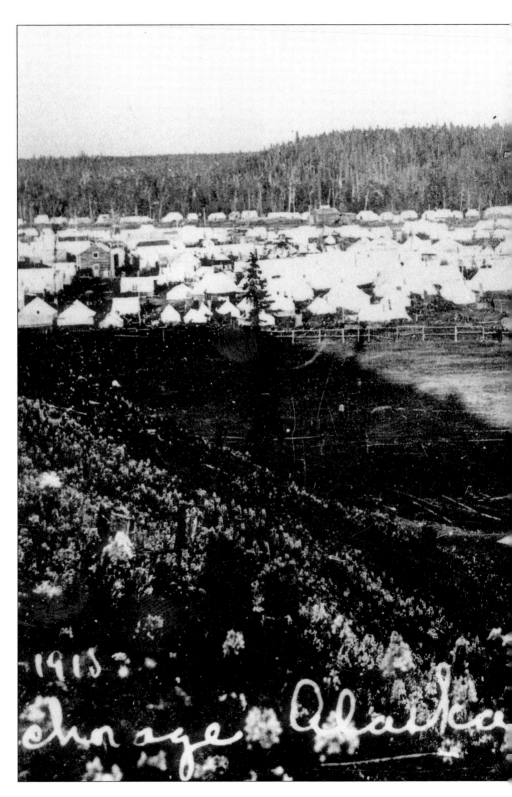

1913
chn age Alaska

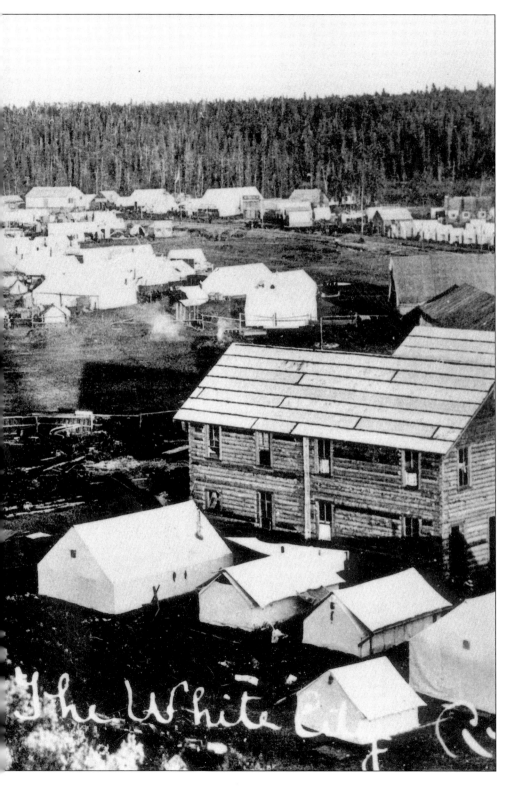

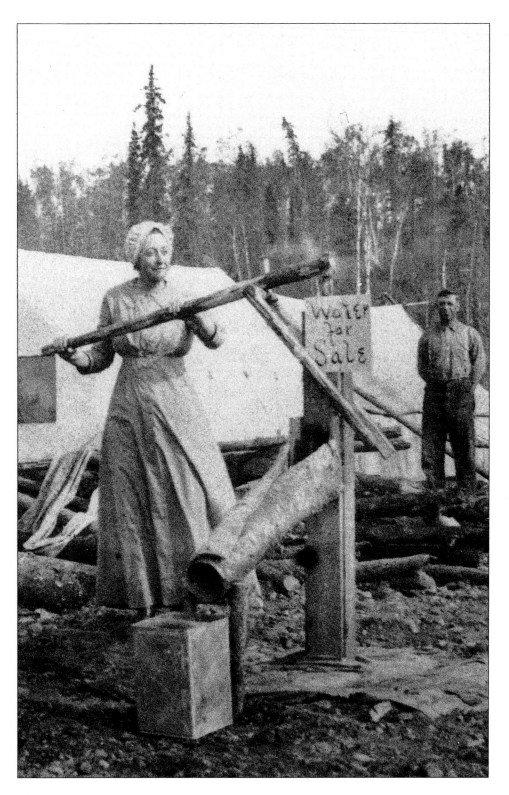

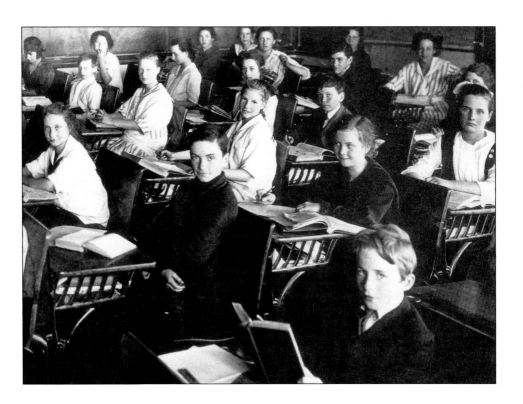

Opposite: Water for sale. Anchorage's first operating water system. A woman pumps water into a kerosene can while a man looks on. A lunchroom and bakery are operating in the tent at left background. June, 1915.

Above: Seventh Grade students at the first Anchorage School. They include Vic Gill, Decema Kimball Andresen, Johnny Dunn, Myrtle Wendler, John Karth, Maurine Anderson and Lawlor Seeley. 1918.

Pages 44 and 45: Two completed spans of the Matunuska River Bridge. Workers can be seen standing on top of the bridge. The bridge served railroad cars only. It was decades before an automobile bridge was constructed. August 23, 1916.

"The average citizen doesn't realize it but there are from 30 to 40 youngsters added to our population here in Anchorage every year. They must sooner or later be provided with schooling facilities, and we have by no means kept up with them," said Councilman C.A. Pollard when asked for his views on the school bond issue that comes up for a vote June 19. "I know that certain families with children coming up that will soon be of school age, are gravely considering the future, wondering whether Anchorage will be able to give them the schooling we feel they are entitled to."
Anchorage Daily Times, May 22, 1928

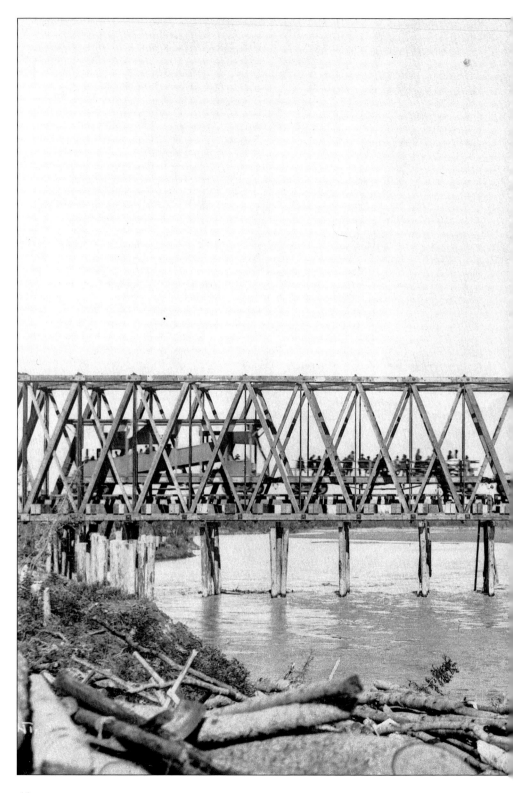

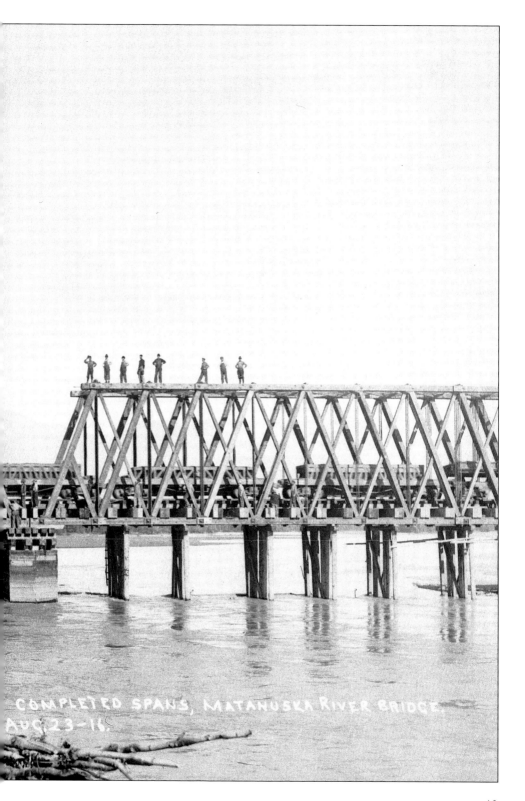

COMPLETED SPANS, MATANUSKA RIVER BRIDGE.
AUG. 23-16.

45

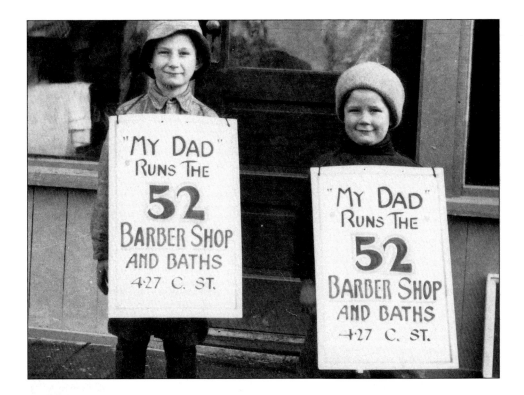

The Alaska railroad bill that passed the Senate Saturday...
gives the President unlimited power to construct or purchase or
both purchase and construct 1,000 miles of railroads in
Alaska. The bill appropriates for the purpose set forth
$40,000,000.

Surveyor General C.E. Davidson said, "I think this is the
most important thing that has so far been done for Alaska,
but this must be supplemented by legislation providing for the
opening up of the public domain and the settling up of the
country.
Daily Alaska Empire, January 26, 1914

*Above: Brothers in sandwich
boards spread the word about their
dad's Anchorage business. c. 1919.*

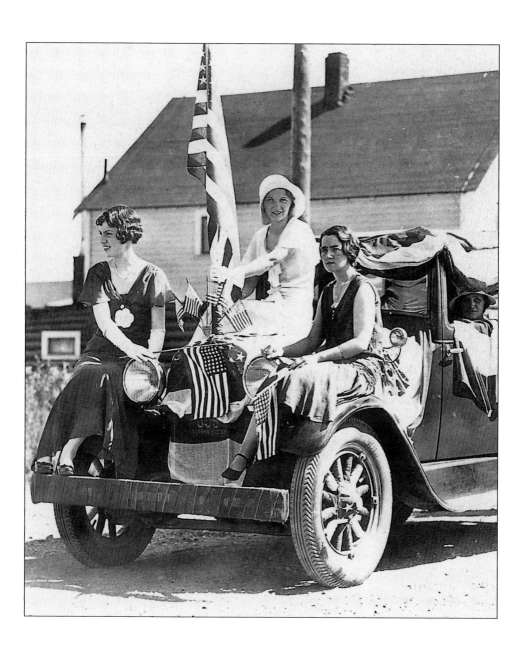

Above: A winning Fourth of July parade float, conceived and driven by Mrs. Walter Muller (in driver's seat). On the hood in red, white, and blue, are Betty, Lillian and Francis. July 4, 1932.

This town of Anchorage is growing fast.... Every steamer brings individuals who wish to start something here. In prospect, we have a bank, a lighting system, a water system, a telephone service, a cement, brick and block manufacturing plant, a cold storage plant, a wholesale mercantile establishment and other highly important enterprises... All this leads to but one conclusion—and that is that Anchorage is destined to evolve into one of the most important towns of Alaska.
Knik News, June 19, 1915.

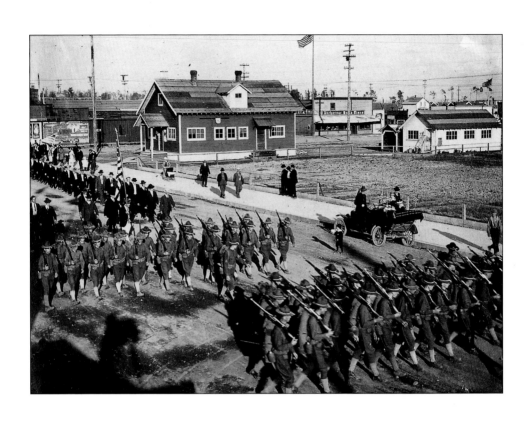

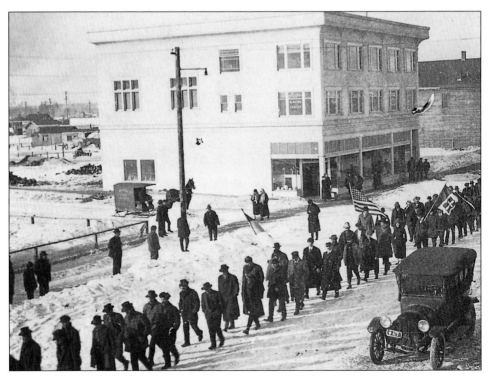

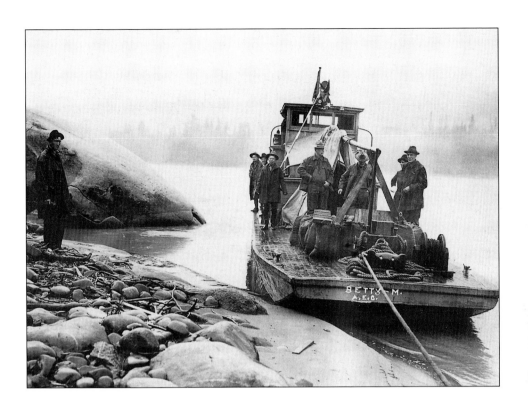

Opposite Top: Parade of uniformed recruits leaving for service in World War I, June 30, 1918. The building used for the Anchorage courthouse stands at rear, left. Center, back, is the Anchorage Daily Times office.

Opposite Bottom: Parade of recruits leaving for military service. The driver of a horse-drawn van equipped with skis watches from the sidelines. March 20, 1918.

Above: Col. Frederick Mears and party going up the Susitna River on the Alaskan Engineering Commission boat, Betty. Mears was chairman and chief engineer of the AEC. 1919.

Pages 50 and 51 Top: Red Cross Benefit ball game during World War I. Matanuska YMCA team. includes Bill Manning, Walter De Long, F.A. Hansen, Bill Iserig, R.D. Chase, Matt Peters, Mr. Locke, C.D. Jones.

Pages 50 and 51 Bottom: Turnagain Arm Team, also at Red Cross Benefit ball game, includes: Don Leach, William Hammer, C.M. Eckman, Eli Dehon, Ray C. Larson, Geo Fowler, Jack Robart.

Pages 52 and 53 Top: Ship Creek waterfront in 1912 showed just three residences, including that of young forester Jack Brown and his wife, Nellie.

Pages 52 and 53 Bottom: Sun cycle, December 21, 1917, looking south from Government Hill. On the shortest day of the year, the winter solstice, the sun barely rises above the horizon.

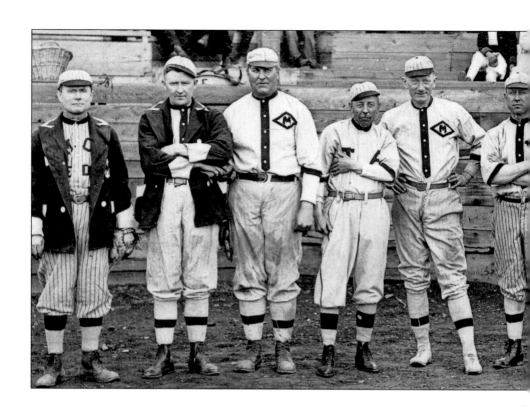

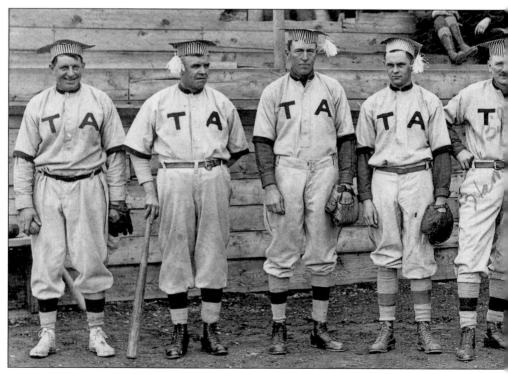

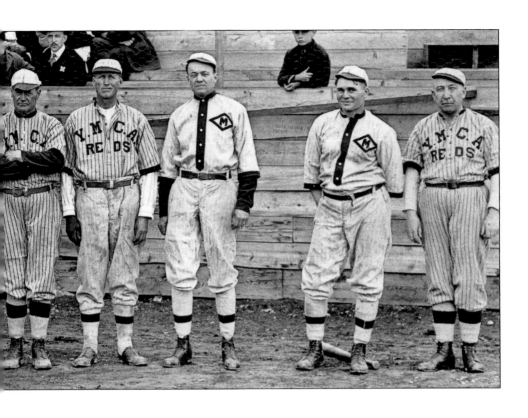

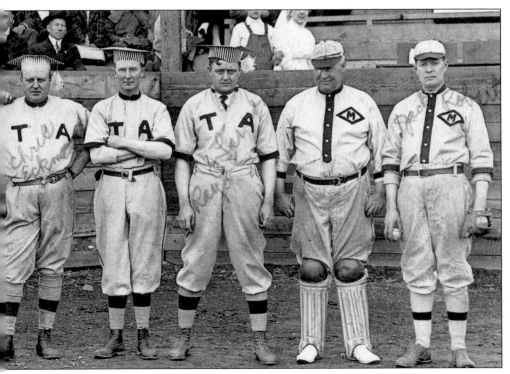

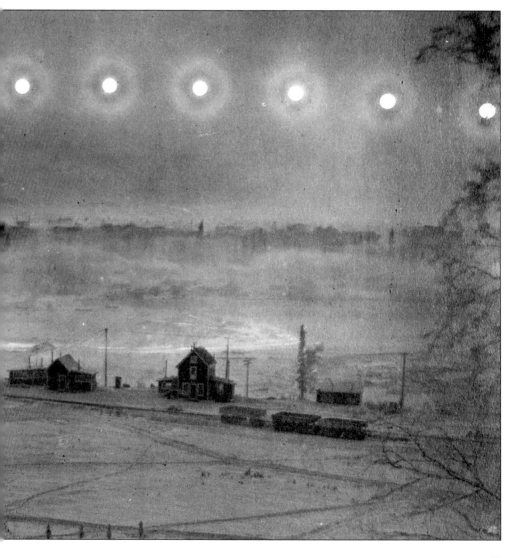

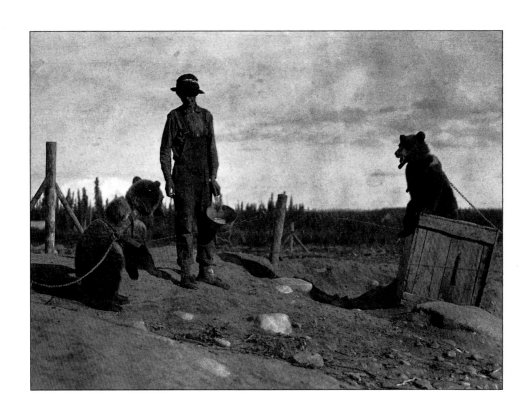

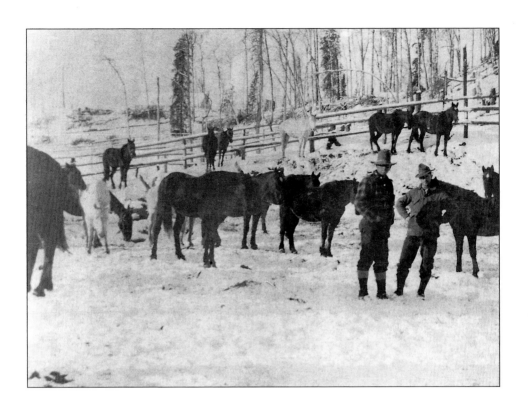

Opposite Top: A young man feeds two captive bears at the Ship Creek waterfront. c. 1915.

Opposite Bottom: "Which shall it be, soup or mosquitoes?" U.S.G.S. Geologist Theodore Sheffield Chapin spent ten years in Alaska. Among his reports were studies of minerals in the Matanuska Valley before 1925.

Above: Red McDonald and Harry Saindon and pack horses in AEC Corral at Ship Creek. The pack horses were used for railroad survey trips. 1915.

Ship Creek Wants Marshal

Ship Creek, March 23. Trouble over the possession of a town lot arose one day last week, and for a time it looked serious, but the disputants got together and adjusted their differences. This dispute is the incentive for a movement to have, if possible, a deputy US marshal stationed here. A petition is being generally signed urging the appointment of L.N. Markle, a sourdough Alaskan, well qualified for the position.

Knik News, March 27, 1915

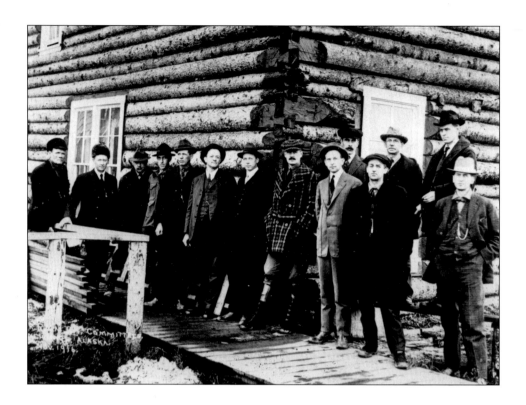

No one here knows anything about the townsite question. Those building are just taking a chance. Two business structures are in course of construction, but cannot be completed on account of the lack of finishing lumber, doors, windows, etc....

Mr. and Mrs. Jack Brown and Mr. and Mrs. McCullough have built comfortable homes and several log cabins are in course of building. There will be little building until title can be obtained to lots.
Knik News, March 6, 1915

Above: The all-male committee that planned Anchorage poses in front of a substantial log building, November, 1916. This is the same Alaska Engineering Commission building seen in the right foreground on page 41.

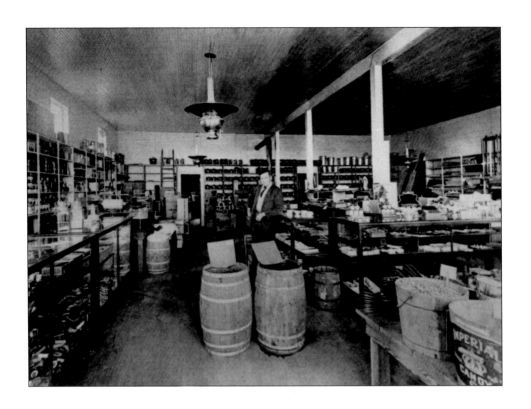

Above: Interior of an early Anchorage store.

Prices, variety and manner of service compare very favorably with the menu in dining car service in the States. The Menu. Oyster Soup 25 cents, Vegetable Soup 25 cents. Salads: Potato 35 cents, Crab $1., Lobster $1., Combination $1., Tuna $1., Alaska Salmon $1., Lettuce 75 cents, Sliced Tomato en mayonnaise 75 cents, Cold Asparagus en mayonnaise 75 cents, Dill pickles 15 cents, Sweet pickles 25 cents, Ripe Olives 25 cents. Fish: Fried or Baked Halibut $1, Mountain Trout with Bacon $1.25, Cracked Crab $1., Alaska Shrimps, per order 50 cents. Hot Roasts: Roast Sirloin of Beef $1.25, Roast Leg of Pork $1.25, Prime Rib of Beef, $1.50, Chili Con Carne 75 cents, Chicken Tamale 75 cents, Hot Roast Beef Sandwich 50 cents, Hot Roast Pork Sandwich 50 cents, Hot Fish Sandwich 50 cents. Cold Meats and Sandwiches: Cold Boiled Ham and Potato Salad $1., Cold Roast Beef and Dill Pickles, $1., Cold Roast Pork and Apple Sauce $1., Extra Cut Prime Rib of Beef $1.25, Cold Roast Chicken with Jelly $1.50, Chicken Sandwich 75 cents, Lamb Sandwich 35 cents, Cream Cheese Sandwich 35 cents, American Cheese Sandwich 35 cents, Imported Sardines 75 cents, American Sardines 50 cents, Van Camp's Pork and Beans 75 cents, Cold Corn Beef and Potato Salad $1. Alaska Railroad Record, May 18, 1920.

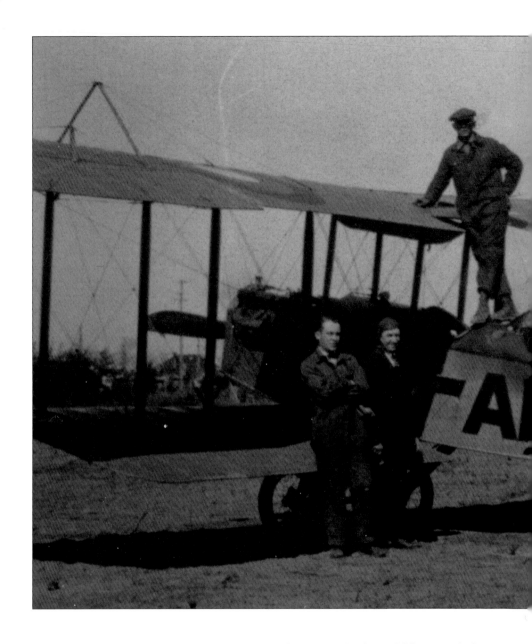

Aerial Game Warden Sam White's watchfulness resulted in $200 fines and 30-day jail sentences for Herman Bluemke, and Emil Giese, 42, both of whom pleaded guilty to killing moose out of season.

White was piloting his own plane when he spotted the men with a dead moose and signaled Warden Jack O'Connor, who was on the ground and later caught the men after a 15-mile snow shoe chase.

Daily Alaska Empire, March 1, 1939

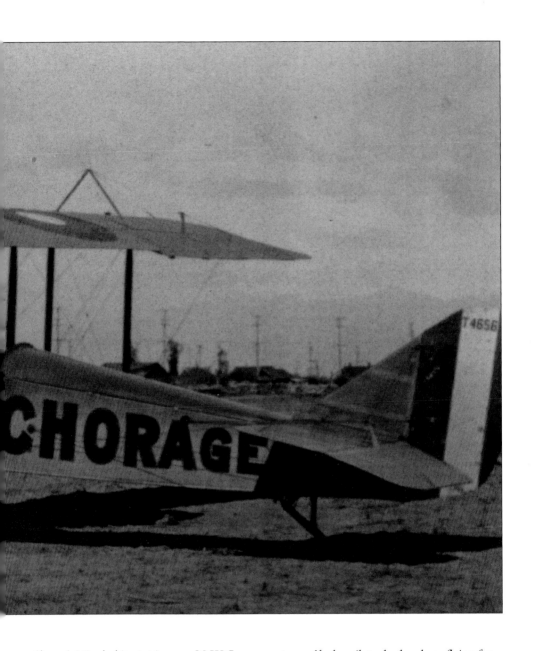

Above: Aviation had its start in Anchorage in the early '20s. Russ Merrill, Anscel Eckmann, Joe Crosson, and Roy F. Jones were some of the early pilots. In 1925, Merrill became the first pilot to cross the Gulf of Alaska. In April 1929, Eckmann completed the first non-stop flight from Seattle to Juneau.

M.W. Sasseen, veteran Alaska pilot who has been flying for Star Air Ways in recent months, is a visitor in Juneau, awaiting the arrival of his wife from the south next Tuesday. Sasseen came down from the Westward [Hotel] a few days ago and has been a guest at the Baranof Hotel.
He will return to Anchorage on the boat with his wife, and will fly with Art Woodley.
The Daily Alaska Empire, April 27, 1939.

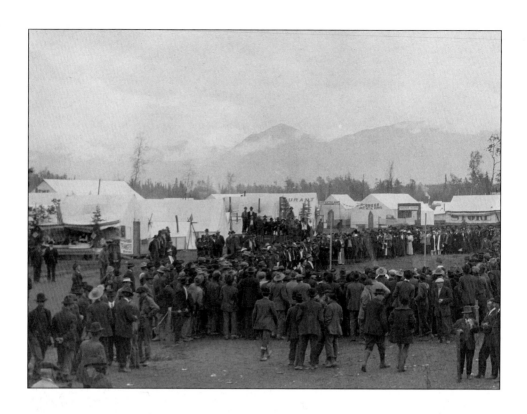

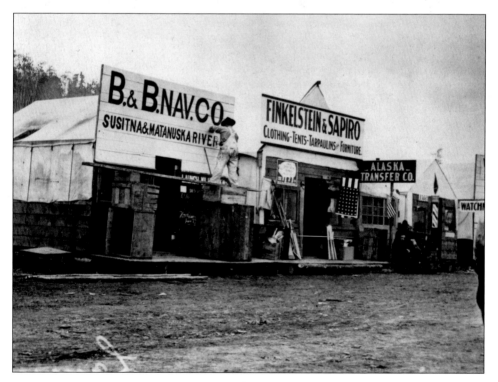

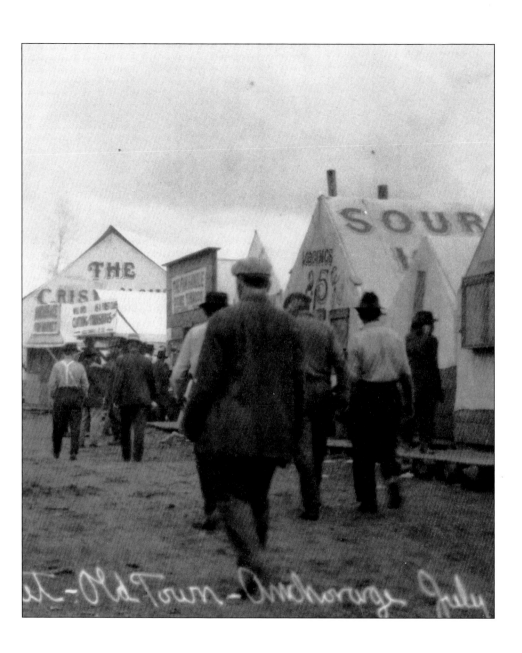

Opposite Top: July 1915 auction of lots in Anchorage. The original townsite plan consisted of 121 square blocks, 300 feet on every side. Each square was bisected by an alley, and subdivided into 12 lots, 50 x 140 feet each.

Opposite Bottom: A street scene in the Ship Creek area of early Anchorage, 1915. Businesses operating out of tents include B&B Navigation Company (Susitna & Matanuska Rivers) and Finkelstein & Sapiro (clothing, tents, tarpaulins and furniture).

Above: Main Street, Old Town Anchorage, July 1915. Photograph by Sydney Laurence, later to gain fame as a painter.

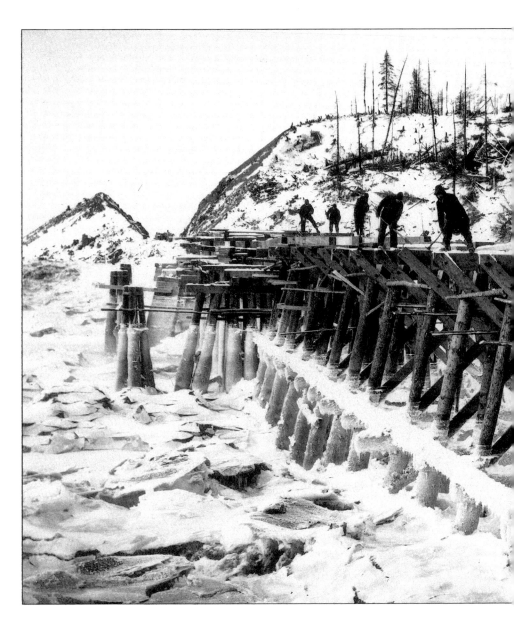

These circumstances convinced me, that no passage (for the Pacific to the Atlantic) was to be expected by this side river (of Cook Inlet), any more than by the main branch.
Captain James Cook's Journal, Volume II, 1785.

Above: Mile 88 out of Seward. Railroad trestle goes up over Turnagain Arm tide flats. Turnagain Arm was named "River Turnagain" by Captain Cook on June 1, 1778, because he was unable to proceed further inland and had to turn his ships.

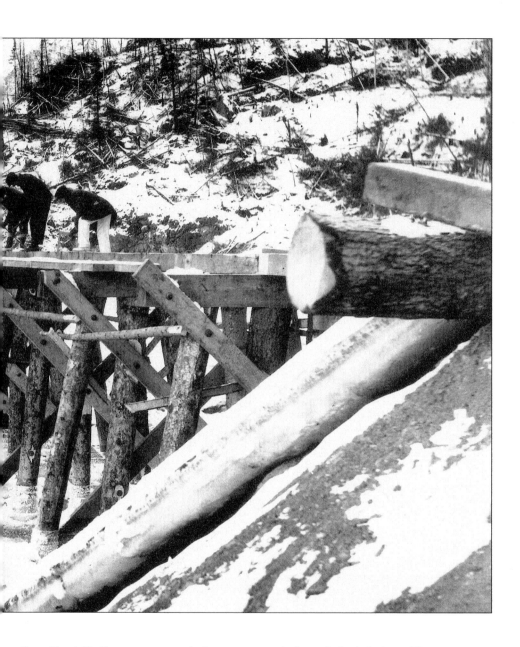

Pages 64 and 65: Government right of way. Railroad track curve in front of a row of tents, Anchorage. 1915.

Anchorage was marked mostly by isolation….There was one boat a week to Seward from Seattle and one train a week to Fairbanks, and if the boat didn't arrive, the train didn't run. Robert B. Atwood, Publisher of the Anchorage Daily Times

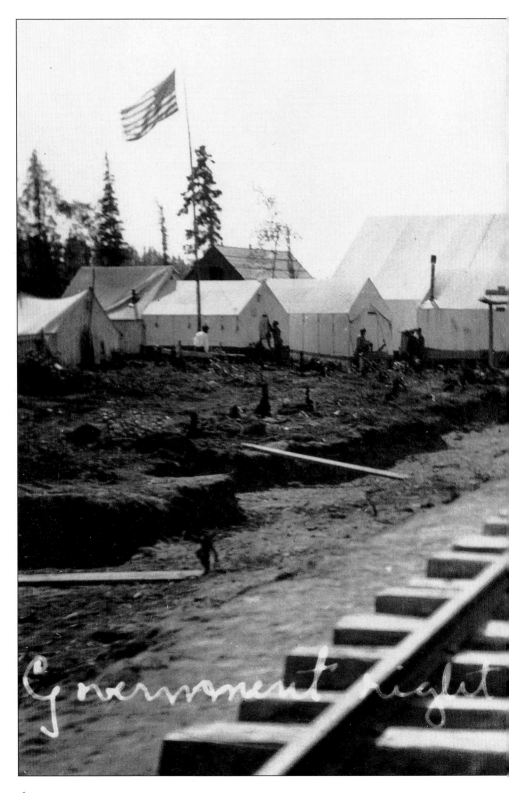

Government Eight

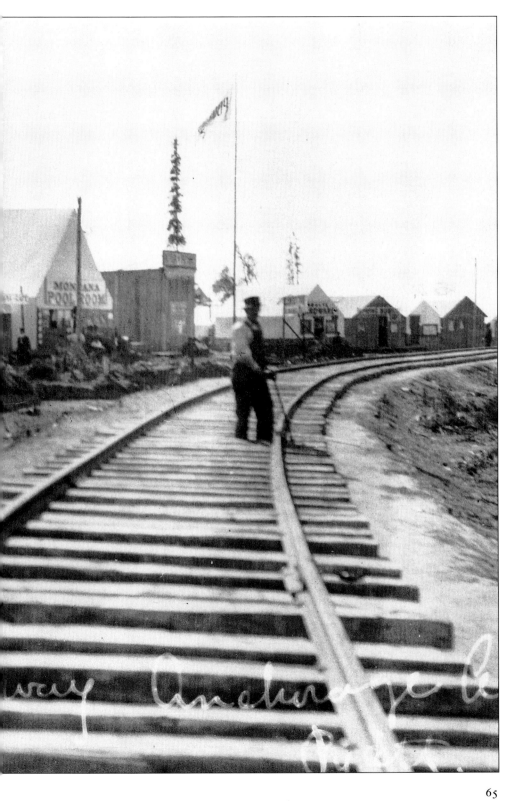

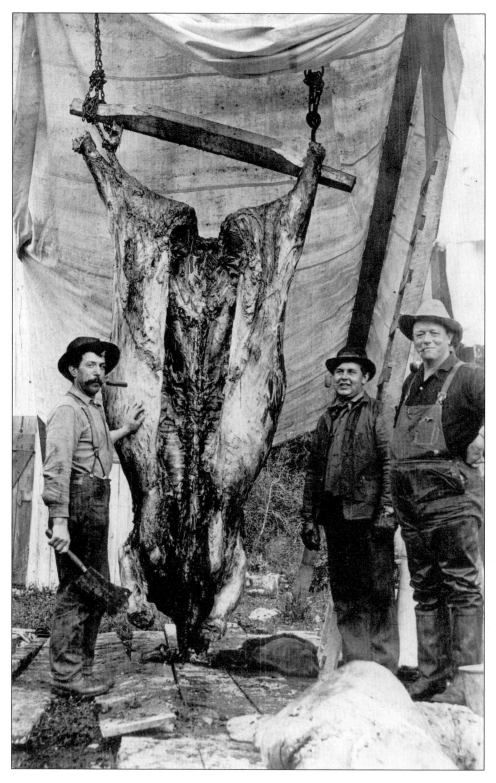

FUR, FISH AND GOLD

For most of its history, the population of Alaska has been very fluid. Nomadic people wandered in search of food and resources. Prospectors moved hither and yon in search of glory holes. Fishermen followed herring runs. Trappers would trap out one area, then move on to virgin forest.

The fluidity of the population is mirrored in the fact that Alaska's economy has perennially suffered from booms and busts. The first boom was in furs, such as the "soft gold" of sea otter pelts. The Russians traded not only in sea otters but also in fur seals, walrus tusk ivory, baleen, beaver, wolf, Arctic or "blue" fox, ermine and marten, in sinew prepared for sewing and in specialized Native garments like the kamleika (a translucent rain-coat of sea mammal or bear gut).

When Russian fur trappers/traders or promylshenniki entered lower Cook Inlet in the late 1700s, the Tanaina Indians occupied the region from Seldovia to the Matanuska Valley and west of Iliamna.

Russian "trade" was often a brutal business, maintained by bloodshed and hostage-taking. For example, in December, 1785, Shelikov, the head of a Russian fur trading company, wrote that during the previous year 400 child hostages had been taken as a pledge of "friendship" with Alaska's Indians and Eskimos. At Kenai, for instance, women and children were taken hostage to force the area's skilled hunters to harvest furs for the Russians. It is no wonder that George Dixon observed in 1786 that the Russians at Kenai were not on friendly terms with the Kenaitze; they never went to sleep without their guns loaded by their sides.

Between 1867 and 1883, fur prices soared in Cook Inlet. Tanaina social organization gradually switched from extended households with many dependents to one-family households nearer trading posts, schools and churches. Men began to express their wealth and status in imported trade goods such as guns, military coats and hats and manufactured boots.

Three prospectors cheerfully dress a steer at Girdwood, 1908-09. Steer were raised in the early days of gold mining at Hope and used for dragging cribbing and cabin logs out of the woods near Girdwood. They were eventually turned loose to graze. When they were judged too fat and lazy, they were butchered for the stew pot. This enormous beef weighed 1,450 pounds dressed. The Crow Creek Mine near Girdwood operated until the 1950s.

Concurrently, high fur prices attracted white trappers, who competed with the Natives. Fox farming began in the Cordova area in 1914, taken up by former prospectors. In the '20s, there was a fox farm at the mouth of the Kasilof River. In other areas, both foxes and mink were raised, fed on fish.

For a long time, the white population of Alaska was quite small. During the era of Russian America, there were never more than 500 Russians in the territory. In 1880, for example, there were only 430 non-Natives in residence, out of a total population of 33,426. It wasn't until 1900 that the non-Natives outnumbered the Natives; there were 34,050 non-Natives and 29,542 Natives in Alaska in this year.

Alaska's fish-canning industry began in 1878 when canneries were built at Sitka and Klawock. A salmon cannery was established in Cook Inlet as early as 1880, and by 1901 there were 45 canneries in the state, mostly in Southeast Alaska. The largest cannery on Cook Inlet was the Alaska Packers' Association Cannery at Kasilof. In 1902, this cannery put up a record pack of 33,000 cases; each case held 48 one-pound cans. Only kings and reds were considered fit for canning.

Cannery operations could be devastating to subsistence practices. By setting a trap at the mouth of a river up which fish swam to spawn, the canneries commonly blocked runs so efficiently that Native fishermen upstream could not catch enough fish to survive the coming winter.

On the other hand, the Tanaina were drawn more and more into the commercial fishing industry. As ethnographer Margaret Lantis points out, "Like the fur trade, [commercial fishing] also stresses individual initiative and holds out the possibility of large rewards for the successful man."

Gold's existence in Alaska was known to early Russian traders, but the first gold rushes in South Central Alaska did not occur until the late 1890s. They occurred in both the Willow Creek region (north of Cook Inlet) and on the Kenai Peninsula.

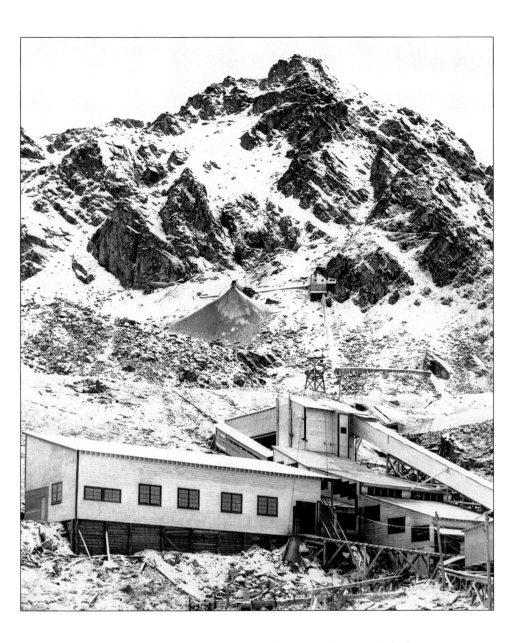

Above: Independence Mine (1936-1943) north of Palmer in the Willow Creek region. Between 1937 and 1940, over 100 miners worked here. Thousands of tourists visit this partially restored hard rock mine today.

Alaska's hard rock mining offers one of the best opportunities for winter activities. Numerous inviting prospects can be had, either on lease or otherwise, where those who know the mining game can apply themselves opening up prospects at all seasons; in the Willow area alone are hundreds of claims presenting opportunities.
Anchorage Times, September 1, 1935

Alaska's major rushes were closely related in many ways to the Klondike or Yukon gold rush. These stampedes occurred between 1898 and 1903, when about 100,000 men and women headed north. Traveling to Dawson from Skagway and Dyea required hard going by foot and then by boat on the Yukon River. Stampeders who didn't feel equal to that physical challenge turned to other promising locations—such as Alaska's Seward Peninsula, and stretches of the Interior bordering the Alaskan waters of the Yukon—which could be reached by sea or river steamer. In 1898 alone, 3,000 prospectors came into Cook Inlet and investigated prospects at Hope, Sunrise, Girdwood, Willow Creek, Susitna and Iditarod. Nome and Fairbanks blossomed.

In 1914, Rev. Hudson Stuck—himself known for thousand-mile journeys by dog sled—wrote of Alaska's population: "The prospectors and miners, who constitute the bulk of the white population, are not often very long in one place. Many of them might rightly be classed as permanent, but very few as settled inhabitants. It is the commonest thing to meet men a thousand miles away from the place where one met them last. A new 'strike' will draw men from every mining camp in Alaska. A big strike will shift the centre of gravity of the whole white population in a few months."

Opposite Top: Harvesting salmon from a fish trap. 1930.

Opposite Bottom: A fishing boat with its catch on deck, headed for a cannery near Anchorage. 1930.

Rushes in Alaska continued through the first decade of the 20th century. For example, on January 10, 1912, two freight sleds pulled by 33 dogs and loaded with 2,000 pounds of gold arrived at Knik. The gold was mined at Iditarod. Large-scale gold mining in some areas continued until World War II, when the federal government closed mines like the Independence.

It was a combination of gold strikes, the existence of copper deposits in the Wrangell Mountains and the potential for coal mining in the Matanuska Valley that stimulated railroad construction in South Central Alaska. The construction of the Alaska Railroad was designed to connect the port of Seward with the agricultural potential of the Susitna and Matanuska valleys (where glaciers had deposited feet of topsoil) and the Willow Creek mining district, eventually connecting to the gold fields of Fairbanks.

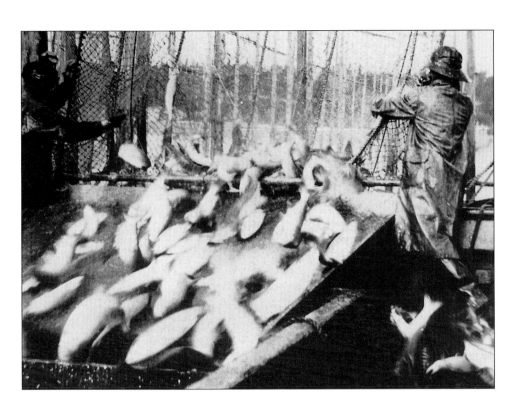

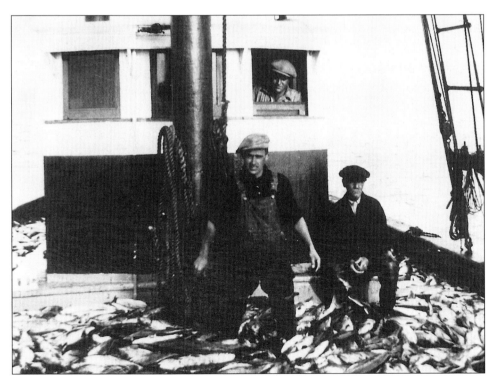

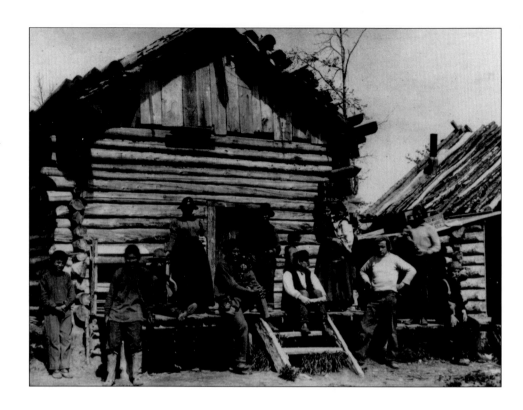

In the spring of 1915, Kenneth Gideon and his friend, Art, became prospectors. They arrived by steamer in Seward seeking gold. Making their way on foot toward Turnagain Arm, they pulled sleds over the snow-covered trail. Hauling their gear up and over Indian Creek Pass south of Anchorage, the men took a break at Fat's roadhouse. Gideon wrote in his memoirs, "Wandering Boy," that, like most of Alaska's roadhouses in this period, Fat's was primitive at best: "A chap known only as 'Fat' went up to timber line on the Anchorage side of the pass and built a 'roadhouse'... a cottonwood pole structure which no self-respecting farmer would use for a stable. But Fat was smart. He knew what those blizzards were like on the Pass and he knew they were frequent. Therefore he reasoned that if he should build a shelter at timber line a goodly percentage of those traveling from Anchorage would be compelled to stop."

Above: Trading post at Susitna Station north of Anchorage. The trading post and nearby Tanaina village were abandoned after the 1918 Spanish Flu epidemic. c. 1898.

Opposite Top: $750,000 in gold arrives in Anchorage from Fairbanks by dog sled, 1917.

Opposite Bottom: A party of gold prospectors getting ready to set off for the Interior. Many prospectors to Cook Inlet unloaded their supplies at the village of Tyonek, where they hired Tanaina guides to take them up the Susitna River. 1898.

Pages 74 and 75: A Gold Rush saloon scene from the silent film "The Cheechakos" being filmed in Girdwood, south of Anchorage, 1924.

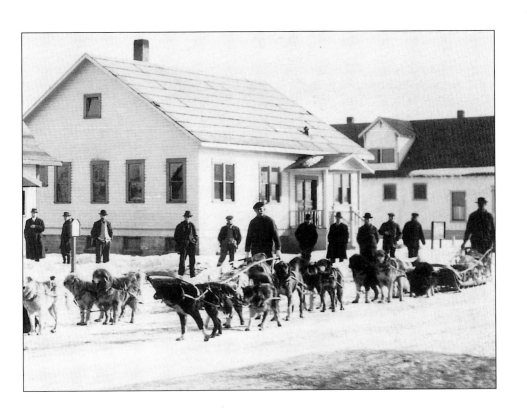

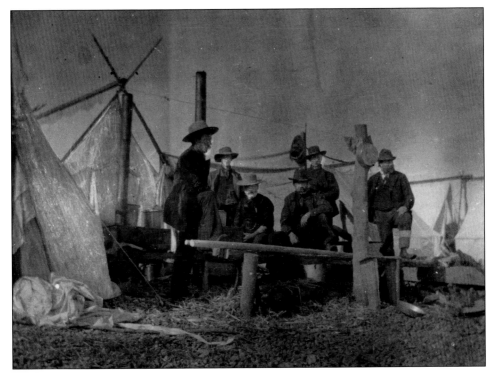

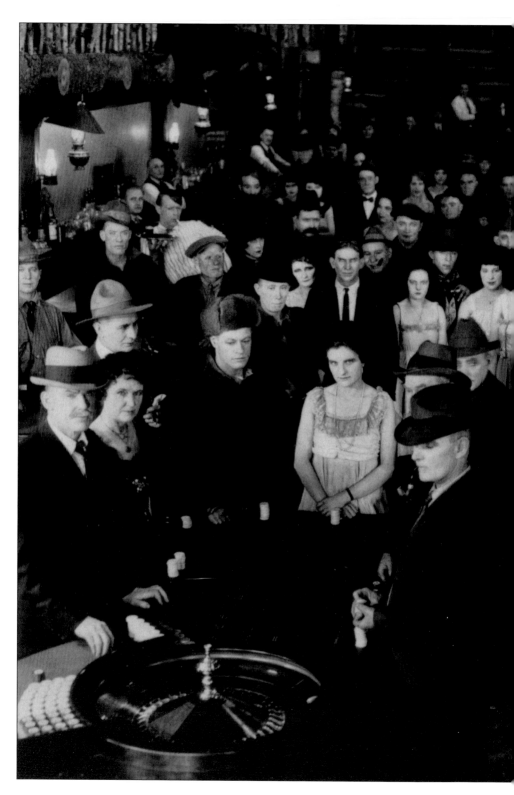

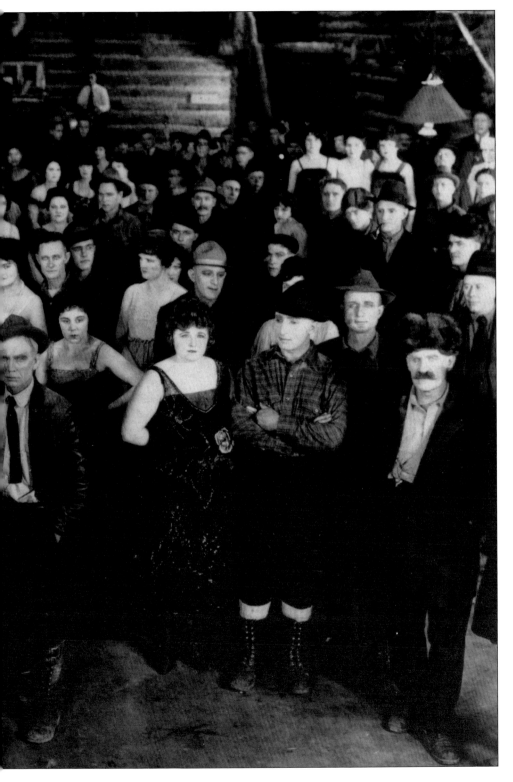

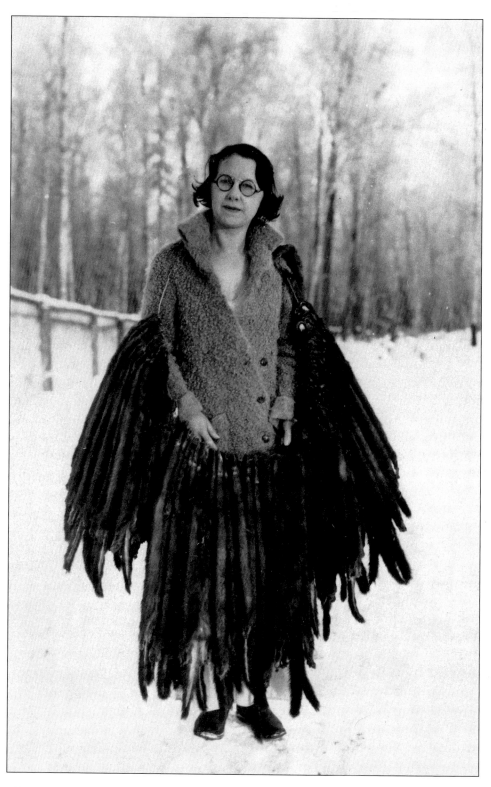

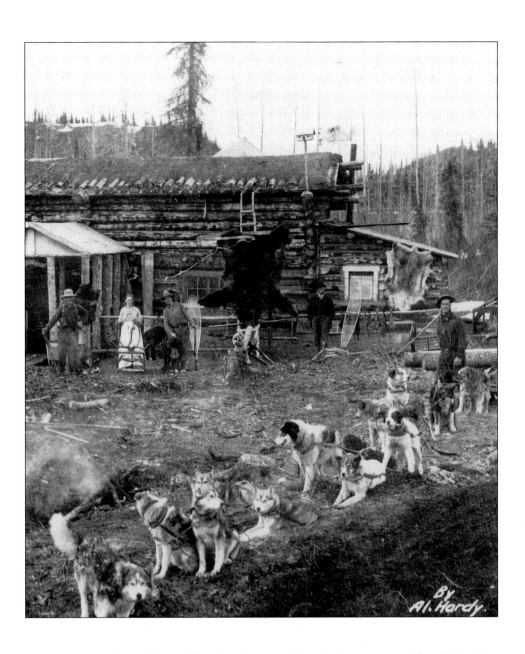

Opposite: Woman with a necklace of mink pelts. The mink were raised on a fur farm near Anchorage.

Above: A trapper and his team return home for a summer's rest before the trails thaw and become impassable. c. 1912.

Four live fox, trapped in the Interior, were sold at Fairbanks for $1,950. Two of them, silvers, brought $750 each.
Daily Alaska Empire, September 21, 1934

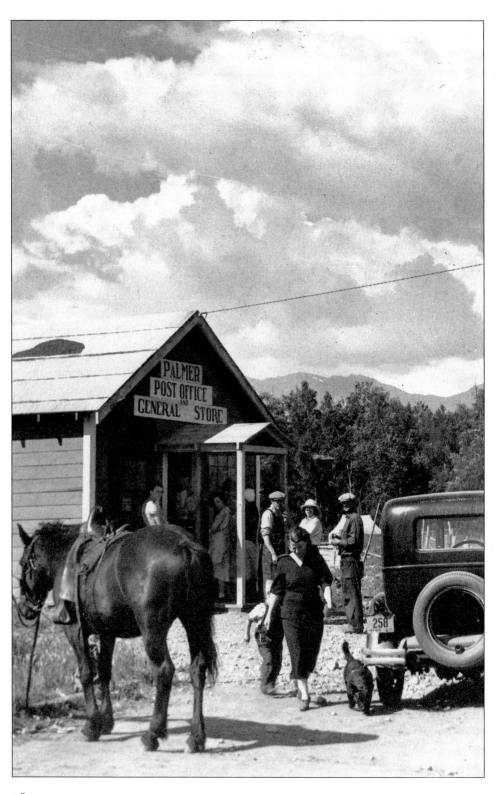

EARLY AGRICULTURE AND THE MATANUSKA COLONY

It was the Russians who introduced agriculture to Alaska's Native peoples—crops such as potatoes, carrots, radishes and turnips. (Baranov writes in 1795 of having "no luck" with cabbage, barley, peas and cucumbers.) Because they did not wish to rely on Spanish California for grain and beef, Russian traders also introduced cattle and pigs and attempted to teach husbandry to the indigenous peoples. Aleuts proved to be poor farmers, but the Russians hoped the Tanaina would be different. According to historian Svetlana Federova, the Russians founded agricultural settlements in 1844 at Kachemak, Kasilof, Kenai, Knik and Matanuska. Optimism about these settlements brims over in the 1859 writings of Russian Alexander Herzen:

"A handful of Cossacks and a few hundred homeless mujiks [peasants] crossed oceans of ice at their own risk, and wherever timeworn groups of them settled in the cold steppes forsaken by nature, the places would begin to teem with life, the fields would sprout forth with grain and herds...."

After the Alaska Purchase of 1867, Russian agricultural settlements lay fallow. Soon, however, American prospectors and entrepreneurs came into the country and tried their hand at basic agriculture—sometimes planting crops in the sod insulating the roofs of their log cabins. At Hope in 1896, George Roll built a store, ambitiously using finished lumber shipped from Seattle. To further distinguish his grounds, he planted vegetable gardens and apple trees.

The Palmer Post Office and General Store was a good place to catch up on the latest news.

Beginning in 1899, the U.S. Department of Agriculture made an attempt to test the feasibility of agriculture in Alaska. The USDA established seven experiment stations where land would be cultivated, livestock raised and crops tested and carefully analyzed. One such station was established at Kenai in 1899. Experiments here were not a success, and the station closed in 1908.

Early photos of the Knik area proudly document private agriculture in action: hotels growing potatoes, oats under cultivation, and prospectors cutting hay for the horses that pulled freight wagons to their gold claims.

When the federal government authorized an Alaska railroad in 1912, its purpose was to ship minerals and agricultural products to an ice-free port. They had in mind coal deposits in the Matanuska Valley—traditionally Tanaina territory—as well as gold from rich claims around Fairbanks.

In 1917, the USDA established the last of its agricultural experiment stations—on rolling hilltop acreage one mile northwest of the town of Matanuska. Frederick Rader was the first agent. The first summer, four acres of land were cleared, and two acres planted with oats. Milton D. Snodgrass ran the station from 1923 to 1929, working hard to attract farmers to the area.

Despite Alaska's fertile valleys and endless supplies of fresh water, it was difficult to attract farmers and ranchers. By 1929 there were only about 4,000 acres under cultivation.

Reaching potential homesteads was part of the problem. A road-building program started in 1905 required every male resident to contribute two day's labor a year. But most roads remained rough trails.

In the 1930s, however, Alaska farming made national headlines because of a planned community near Palmer. Palmer had been founded in 1916 as a stop on the ARR branch line to the Chickaloon coalfields, but little development took place until the optimistic architects of President Franklin D. Roosevelt's New Deal hatched the idea for the Matanuska Valley Community, or Matanuska Colony. Final plans were drawn up in January, 1935. Colonists were plucked from drought-stricken areas of Michigan, Wisconsin and Minnesota.

In all, 202 families came north as part of this resettlement project of the Federal Emergency Relief Administration (shortly to be called the Works Progress Administration or WPA). The colonists, mostly farmers and their families, drew lots for "forty acres and a homestead." The deal included a house, well, barn, out-

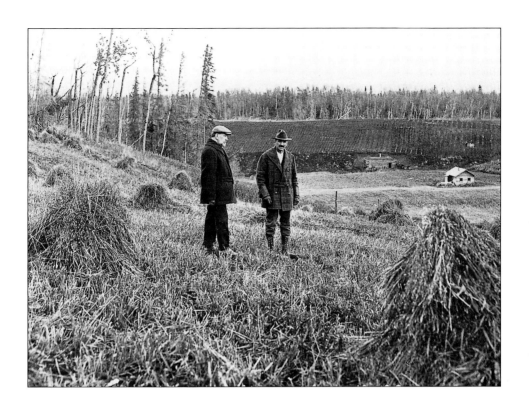

buildings and livestock, plus a loan of $3,000 at 3 percent interest to pay for them. The families also received temporary housing, a $75 monthly food allowance, medical assistance, and aid in clearing the land and building their homes.

History professor Henry Dethloff wrote in 1967 of the Matanuska Colony, "The FERA viewed the resettlement project as an effort at relief and rural rehabilitation, while the Department of Interior sought to use it as a demonstration that Alaska was a suitable place for the colonization to promote immigration into Alaska. Military considerations may have also prompted interest in populating Alaska."

Texas-born architect David R. Williams, who was to design dozens of resettlement projects, created five residential floor plans for the enterprise his personal papers dubbed "Matanuska Valley: The Latest Frontier." Some of Williams' blueprints called for construction of logs sawn flat on three sides, with side-gable roofs. Four of the plans were for one-and-a-half-story houses, with

bedrooms in the half-story. None of the houses were given basements or full foundations. Barns had only one design, a 32-foot cube with a gambrel roof. The colony was supposed to produce dairy products for itself as well as Anchorage, and thus town plans included a creamery, cannery and warehouse.

The first colonists arrived May 10, and were confronted by frustrations and chaos on every hand—frustrations typical of those generated by an absentee government. Construction workers had arrived only four days earlier. There were horses but neither wagons nor harness; coffee beans but no coffee grinders. Colonists sent telegrams of complaint, and on June 24 Senator Arthur H. Vandenburg described the project as a "crazy venture." Families made do in a tent city while permanent buildings (including a trading post, churches and schools) were constructed. Not until November 10 did every family have a roof over its head.

The family of Raymond Rebarchek claims to occupy the very first colony house completed. That same year, the family built a 12 x 16-foot log wellhouse/sauna. The barn was finished in 1936. Rebarcheks still live in Palmer. Another colony family was the Kertullas, whose descendants have now gone into state politics.

The Matanuska Colony project was not entirely successful. Some disgruntled colonists left because of bureaucratic inefficiencies. Among other things, they found the barns too small, constructed on poor foundations and insufficiently partitioned. Fifty families left, but thousands of applications were already on hand; in 1936, replacement families began to arrive. By the end of the second year, some colonists reported incomes of over $10,000 from farming, but most had accumulated an average debt of $5,000.

The unpredictable climate and the freight costs needed to take products to outside markets brought the colonists defeat. Nevertheless, the publicity the Matanuska Colony brought Alaska was significant.

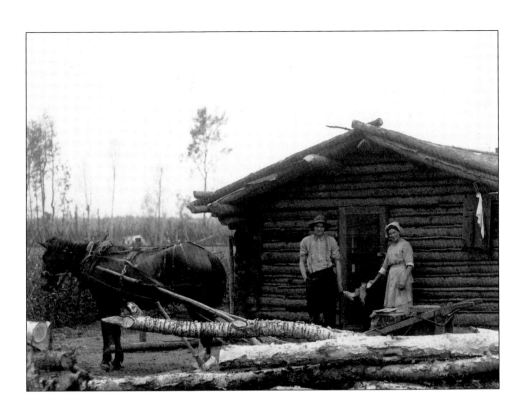

Above: E.L. Saindon's ranch in its first year. This ranch was a few miles north of Matanuska Junction. This photograph was taken of the rough 'prove-up' cabin, just before the Saindons built a new house.

Pages 84 and 85: The spectacular Matanuska Glacier. In 1923 Mrs Warren Harding said "I cannot tell you the surprise and delight in finding a country of such beauty." She was accompanying the President to Alaska to drive the golden spike at Nenana marking the completion of the railroad from Seward to Fairbanks.

Pages 86 and 87: Colonists move from tents to their new homes. A team and wagon loaded with benches, a stove, mattresses and other household goods gets ready to move out.

Visitors in Anchorage during the Fur Rendezvous and in Fairbanks during the Ice Carnival were attracted to displays of 'Matanuska Maid' products in local show windows, and discovered bills of fare listing eggs, milk, butter, meat products, cheese and vegetables grown in the Valley and processed in modern creamery, cannery and meat handling plants located at Palmer, the civic center of the Colony. A modern hatchery produced about 30,000 chix [sic] in 1937 which were sold to Colonists interested in poultry raising as a means of revenue. Daily Alaska Empire, June 12, 1938.

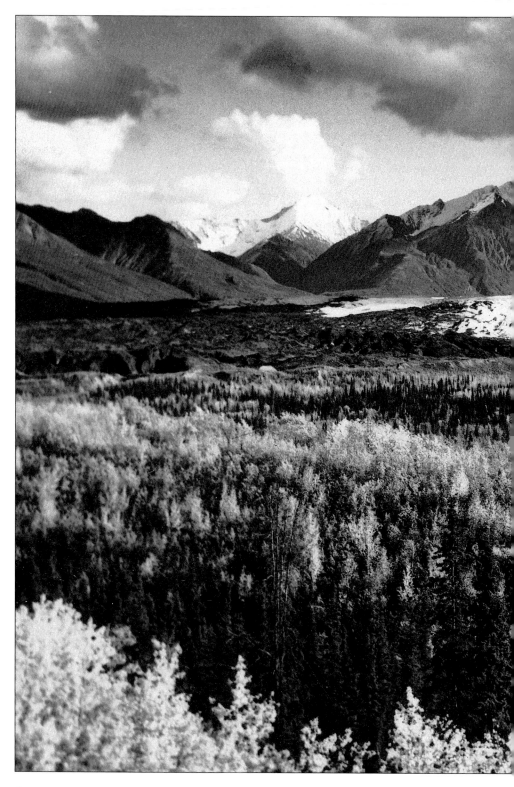

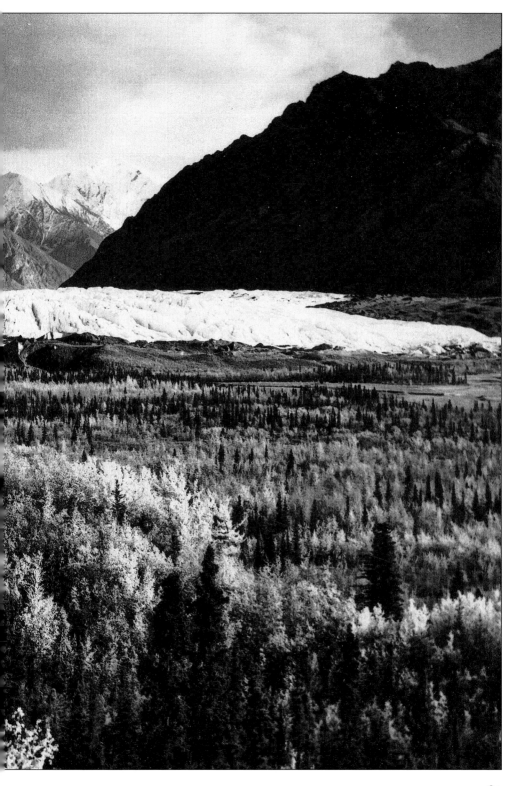

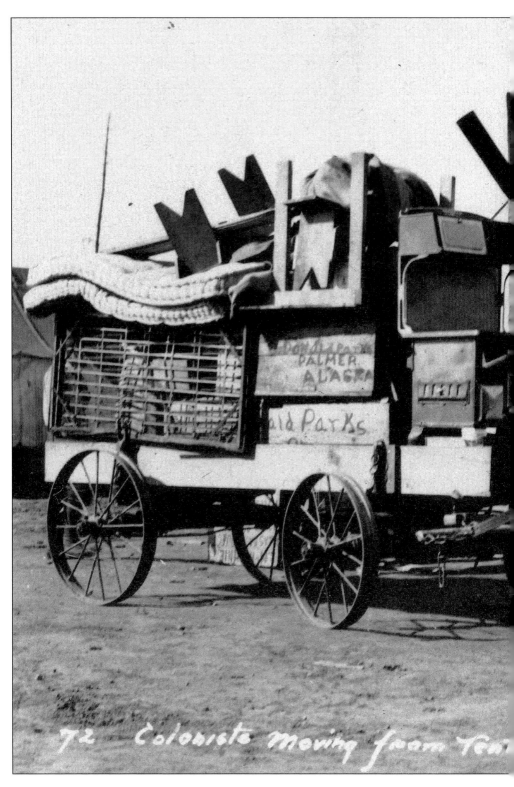

72 Colonists moving from Ten

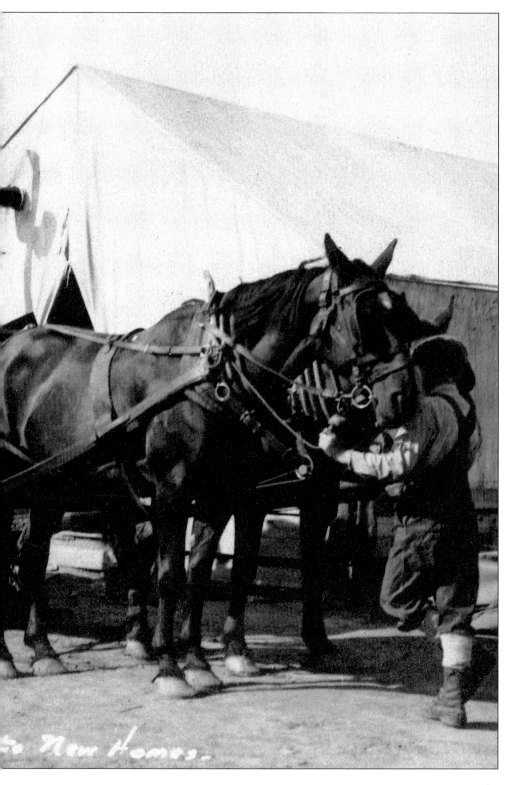

to New Homes.

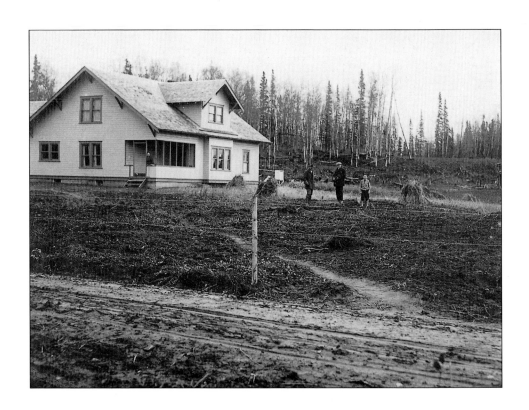

At a recent meeting of the Settlers Association of Matanuska, the advisability of erecting a small cannery came in for a great deal of discussion... locally packed foodstuffs would find a ready market at the mines and in the towns on the railroad. With the freight adding to the cost, outside vegetables would not compete with local pack and the trade should prefer the Alaska product after it was once sampled, any way. *McCarthy Weekly News, April 1924.*

Above: U.S. Agricultural Experiment Station at Matanuska with Mr. Rader in charge. October 12, 1918.

Opposite Top: First year hay crop, 2.5 miles north of Matanuska Junction. September 27, 1916.

Opposite Bottom: Oscar Beyland clearing land at the Matanuska Colony. c. 1936.

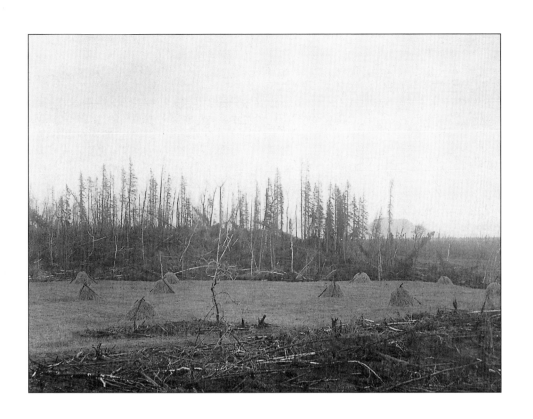

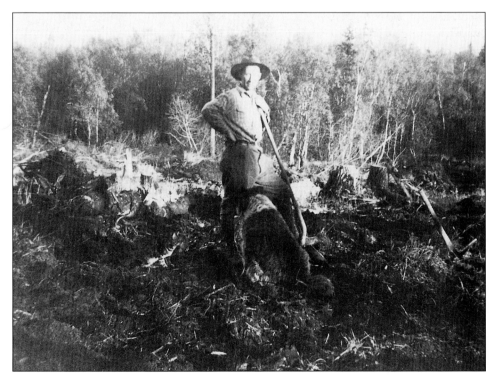

Mrs. Leon Blanc, wife of a farmer with new found hope and vision now in Matanuska, is aboard the Baranof bound for fertile Palmer fields with her six children to join her husband. The Blancs fought the dust and the depression like so many farmers. They heard of rich fields to the North, fabulous soil in the lee of magnificent Alaskan peaks. Finally Leon Blanc was informed that his name had come up on the list.

A year ago, Leon Blanc left his family in Colorado where they had migrated from Wyoming, and went to Matanuska to break the soil of his new land.

And so, today, Mrs. Blanc sits with six children in a Baranof stateroom at the dock in Juneau.

Daily Alaskan Empire, April 29, 1939.

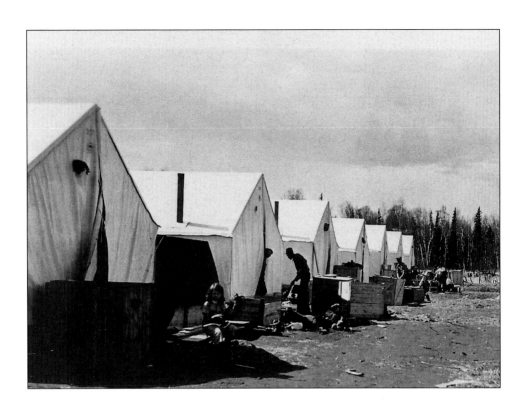

Opposite: View showing the depth of soil near Mile 8 on the Chickaloon Branch of the ARR in the Matanuska Valley.

Above: Colonists make themselves "to home" in canvas tents, Palmer. c. 1935.

Pages 92 and 93: A typical Matanuska Colony homestead on Fishhook Road in Palmer. The gambrel-roofed barns were often logs on the ground floor and lumber above. Many of these picturesque barns still stand.

According to W.A. Rockie, Northwest soil conservation chief, nearly 100 of the Matanuska colonists left their farm work for army base work at Anchorage last summer. Conservation Chief Rockie, speaking in Spokane, howled about debt reductions demanded by farmers. He failed to mention the nonproductive rat hole into which these debts have gone. Alaska Frontier, March-April, 1941.

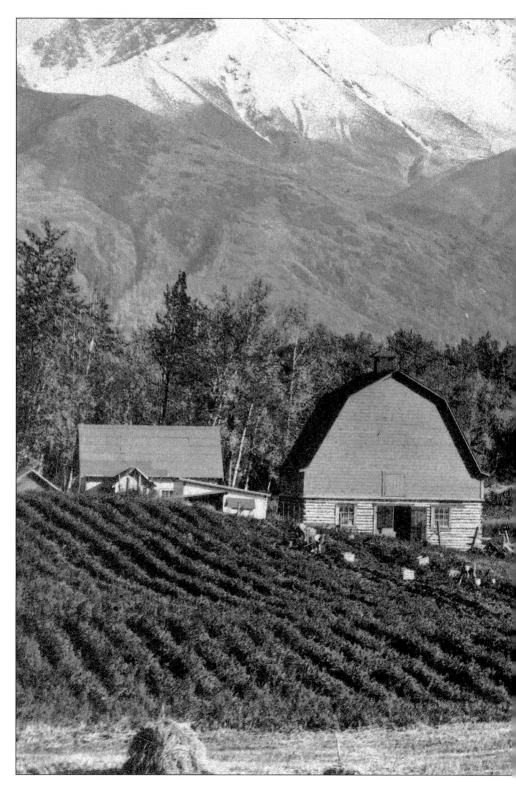

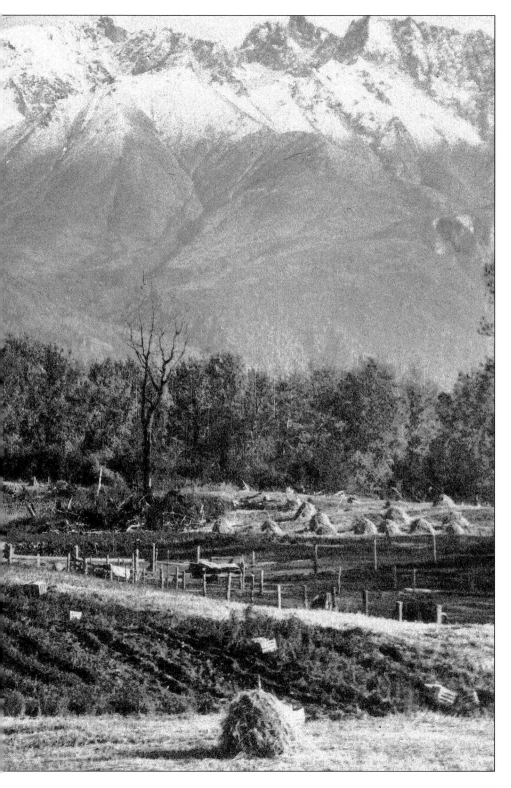

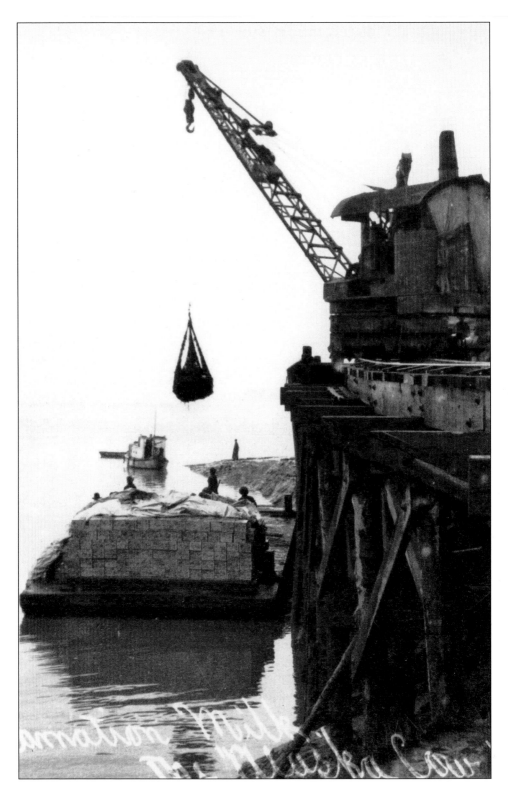

ANCHORAGE COMES OF AGE

During its first five years, Anchorage was administered by the Alaska Engineering Commission, the construction arm of the Alaska Railroad. The AEC laid out the townsite, built the school, inspected water systems, established a firebreak and declared alcohol illegal. Anchorage was a railroad town, and some of its nicest homes were the 19 bungalow-style cottages built for rent to railroad employees.

Slowly, however, Anchorage diversified and came of age. One of the first signs of its maturation occurred on November 23, 1920, when Anchorage shed control of the AEC and incorporated as a first-class city. On this day, Anchorage had a population of 1,856. It could boast a lakeside resort, a movie theater, hotels and restaurants, a community chorus and city band, a baseball park with grandstand seats, an hour-long bus tour for visitors and a winter carnival with sled dog races. Leopold David, born in Germany in 1881, was elected the town's first mayor. David had trained as both a pharmacist and a lawyer, and was appointed U.S. commissioner in Knik in 1910. In 1915, he moved to Anchorage, where he practiced law. In 1917, he built an attractive bungalow on West Second Avenue near the AEC cottages.

A second window into Anchorage's future opened in July, 1923, when the whole town turned out to clear 16 acres along Ninth Avenue for an airfield. The preparations proved their worth on July 6, 1924, when 24-year-old barnstormer Noel Wien took the controls of an open-cockpit biplane parked on the Park Strip. Wien followed the railroad north, and landed safely at Weeks Field in Fairbanks—completing the first flight between the two cities. The flight was not entirely smooth. An hour out of Fairbanks, Wien encountered heavy smoke from wildfires near Healy, which obscured visibility at a critical time. But the gutsy aviator persevered, and aviation in Alaska took a giant leap forward.

In the 1930s, international tensions heightened, but little attention was paid to the defense of or mobilization

Unloading cases of canned milk from a barge at the Anchorage waterfront, 1910-1919. Carnation was jokingly called "the Alaska Cow."

95

of Alaska. Anthony Dimond, Alaska's voteless delegate in Congress, was sure that Alaska was strategically important. "What is the use of locking one door and leaving the other one open?" he asked, pointing out the value of Alaska's timber, mines and people. In 1934, Dimond sponsored a bill to set aside $10 million to build an army air base and naval station. But the bill failed.

Finally, in 1939, the federal government realized that isolationism could not continue. The Joint U.S. Army-Navy Board mandated construction in Alaska, and Brigadier General Simon Bolivar Buckner Jr. was named commander of the newly-formed Alaska Defense Command.

Military buildup had enormous effects on the growth of Anchorage. In June, 1940, the U.S. Army began construction of Fort Richardson, a permanent air base just north of Anchorage, on the upper regions of Ship Creek. Fort Richardson included Elmendorf Field, its hangars, and housing for 7,000 troops. Housing and support facilities for an additional 7,500 personnel were authorized in December, 1941. Elmendorf Field was completed the following year.

However, fort and field could not operate efficiently until a ground link to the Lower Forty-Eight was in place. The bombing of Pearl Harbor on December 7, 1941, reinforced the need for this umbilical, and accelerated its construction. As soon as the ground thawed, the military began building a road that would connect Washington state and Alaska—the Alaska-Canada Military Highway, or Alcan. This military supply line was dedicated on November 20, 1942.

For Alaskans, Pearl Harbor was not the only sneak attack of the war. Japan also attacked Dutch Harbor, 750 miles west of Anchorage, on June 3, 1942. Enemy Zeroes returned the following day. This was the beginning of a little-known war in the Aleutians which continued until August, 1943. One of the immediate consequences of the attack on Dutch Harbor was that the Eleventh Air Force was organized at Fort Richardson in 1942. After the war, the Eleventh was renamed the Alaskan Air Command. In 1950, the army moved to the eastern part of the base and named it Fort Richard-

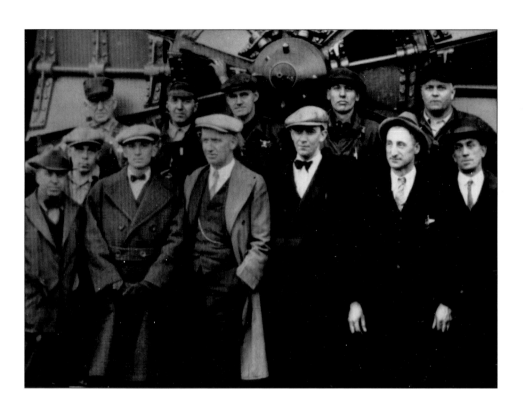

Above: Alaska Railroad mechanics pose in front of an engine equipped for winter with an enormous rotary snowplow. Bill Stolt is second from left, in front. Bill Cannor is in the back row, third from left, dark suit. c. 1920.

Alaska to Uncle Sam

*I'm a full-grown, proud-souled woman,
And I'm getting tired and sick
Wearing all the cast-off garments
Of your body politic.
If you'll give me your permission,
I will make some wholesome laws
That will suit my hard conditions
And promote your country's cause.
Daily Alaska Empire, April 27, 1920.*

son. The site is now known as Elmendorf Air Force Base. (When the President of the United States visits Anchorage, he lands here rather than at Anchorage International—for security reasons.)

In September, 1946, another link was established between Anchorage and the rest of North America: Northwest Airlines began service between Anchorage and Seattle using DC-4s. The Northwest flights landed at the Elmendorf Field Air Terminal. Less than a year later, in July of 1947, Northwest initiated service from the U.S. to Asia, using Anchorage as a refueling stop.

Gradually, log cabins and Quonset huts gave way to ranches and duplexes. Subdivisions were laid out, one famous one marked with toilet paper as the developer strode ahead of the caterpillar tractor.

The burgeoning city needed to keep up with the times through modern information sources. In 1948, KENI, the second radio station in Anchorage went on the air. Owned by Alaskan industrialist and millionaire Austin E. "Cap" Lathrop, the station was housed in a notable piece of Art Deco design, a sleek, two-story, reinforced-concrete building designed by one of the architects who worked on Lathrop's Fourth Avenue Theater.

By 1950, the Anchorage area had a population of 43,315—600% more than in 1940. It also boasted parking meters, automatic telephone service, a symphony orchestra, traffic lights and home mail delivery.

The final step in Anchorage's progress from railroad construction headquarters to modern city was the opening of the $12.5 million International Airport on December 10, 1951. The airport became a busy place serving trans-polar passengers and airlines flying between Asia and Europe, as well as domestic carriers.

On any mild, sunny day, strolling along Anchorage's Coastal Trail, residents and visitors alike readily agree with Captain James Cook about the region. "The climate," Cook noted, "seemed to be as favorable for a settlement as any part of the world at the same degree of latitude."

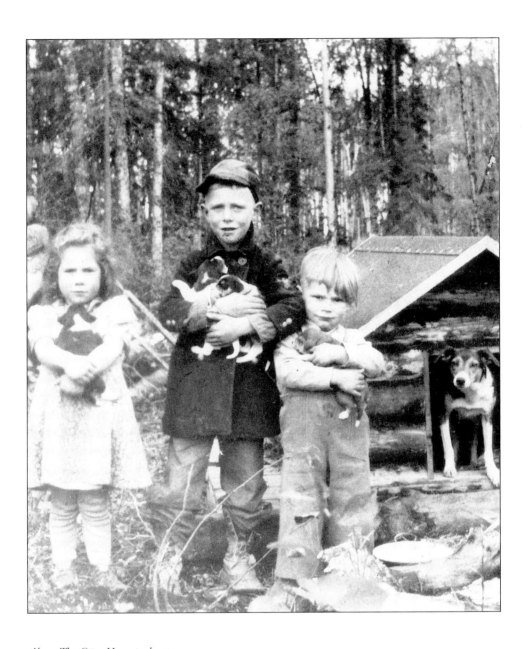

Above: The Otter Homestead was established where the modern site of Anchorage International Airport is now located. Playing with puppies, from left: Martina Otter, David Kincaid, George Otter. Sand Lake area, mid 1940s. Today, Kincaid Park, which borders the airport on the north, is an important forested playground for residents and favorite habitat for moose.

From a commercial standpoint it is believed there should be established in Alaska three principal airways.... This system of airways would connect all of the larger cities and important centers of Alaska and would cover practically the entire Territory.

Army Captain Henry H. Arnold, commmander of a squadron of Martin bombers that flew from Fairbanks to Seattle in nine hours and thirty minutes in 1934.

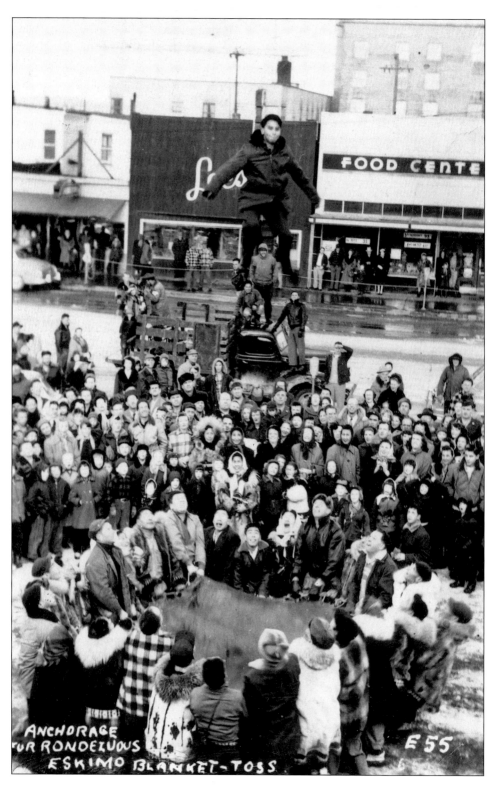

ANCHORAGE
FUR RONDEZVOUS
ESKIMO BLANKET-TOSS

E 55

Opposite: An Eskimo "blanket" (walrus skin) toss during the annual Anchorage winter festival called Fur Rendezvous, or Rondy for short.

Above: Breakfast at 6 A.M. during a fishing trip to Fire Lake. June 5, 1921. Fire Lake is now part of a residential area near downtown Eagle River, but in 1921 it was surrounded by a wilderness.

Pages 102 and 103: Aerial photograph of the Anchorage waterfront. c. 1947.

The latest news received here concerning the government railway project indicates that Ship Creek, on Knik Arm, will be a very important—if not the most important—base of operations in the big scheme of development. The information available, not official, it is true, but bearing the stamp of authenticity is to the effect that three units of a thousand men each will be employed at the inception of construction work this spring. The first unit will begin at Ship Creek and build toward the Matanuska coal fields; a second unit will start at Ship Creek and work toward the end of the Alaska Northern road; the third unit will be employed on the Seward end of the line.

Should this plan of work prove to be the one adopted by the commission, it will readily be seen that at Ship Creek a highly prosperous commercial center will spring up.
Knik News, April 10, 1915.

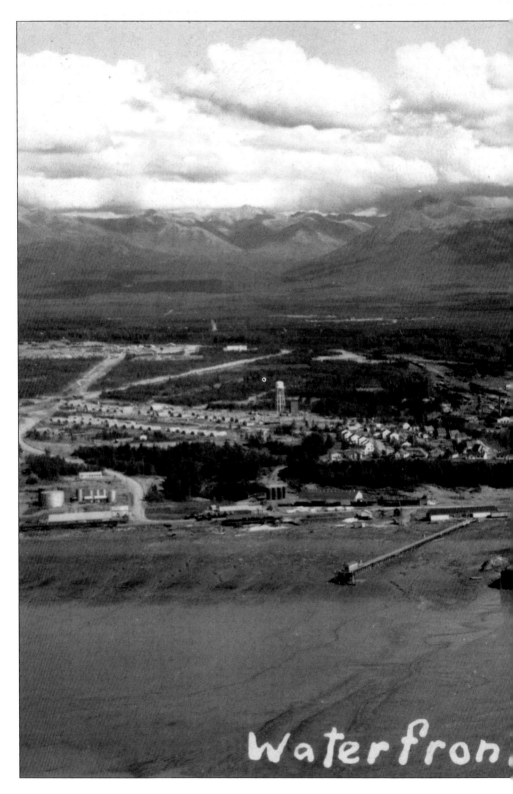

Waterfron,

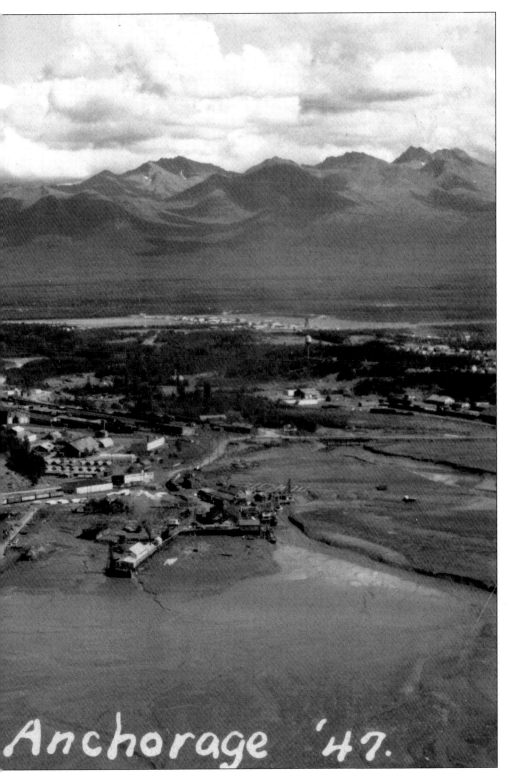

Anchorage '47.

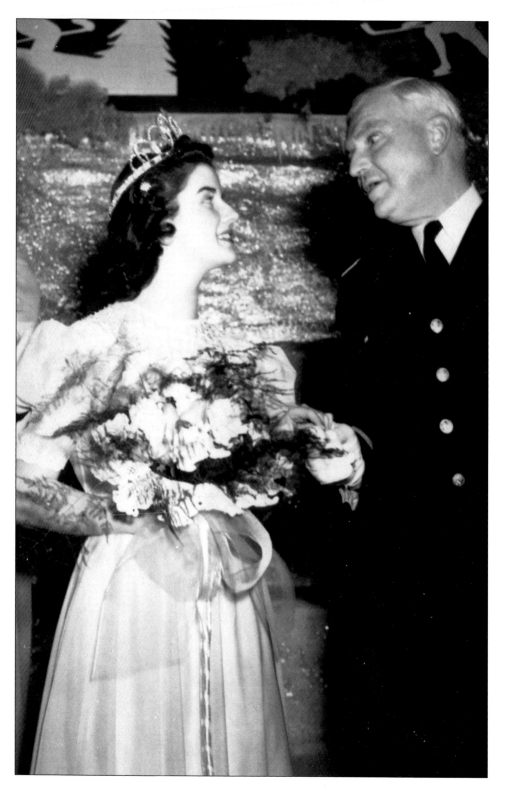

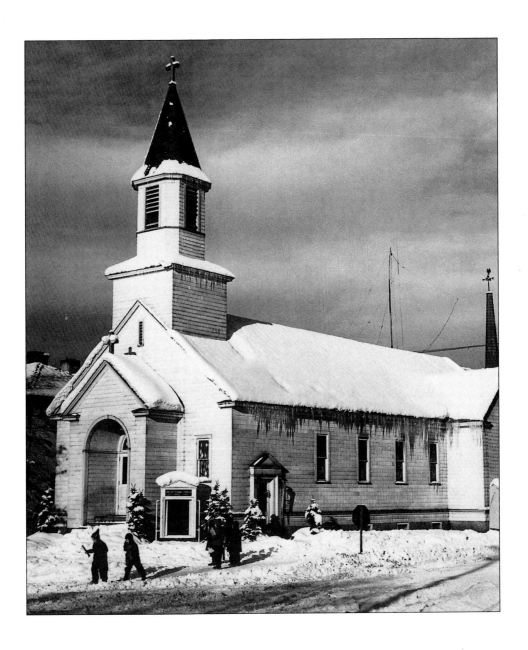

Opposite: At Anchorage's Fur Rondy Coronation Ball in 1941, Queen Patricia Chisholm poses with Brigadier General Simon Bolivar Buckner Jr., Com. Gen. ACC during World War II. Buckner arrived in Alaska in July 1940 to oversee the Territory's fortifications. He was given a budget of $300 million. He left Alaska in 1944 and was killed at Okinawa, Japan on June 18, 1945, one of the highest ranking officers lost in the war.

Above: Children in snow suits play in front of the Presbyterian Church in winter. c. 1940.

Airplane fare between Seward and Anchorage, 114 miles by the Alaska Railroad, is $15, and between Anchorage and Fairbanks, 356 miles by railroad, $50. These one-way fares are 10% lower for round-trip passengers.
Daily Alaska Empire, Oct. 20, 1932.

Above: Boeing Bombers at Merrill Field, 1934. Flight in command of Lt. Colonel Henry "Hap" Arnold.

Opposite: Carving out an air link. The runways for Anchorage International Airport were created by clearing former homesteads. The airport's official opening was on December 10, 1951.

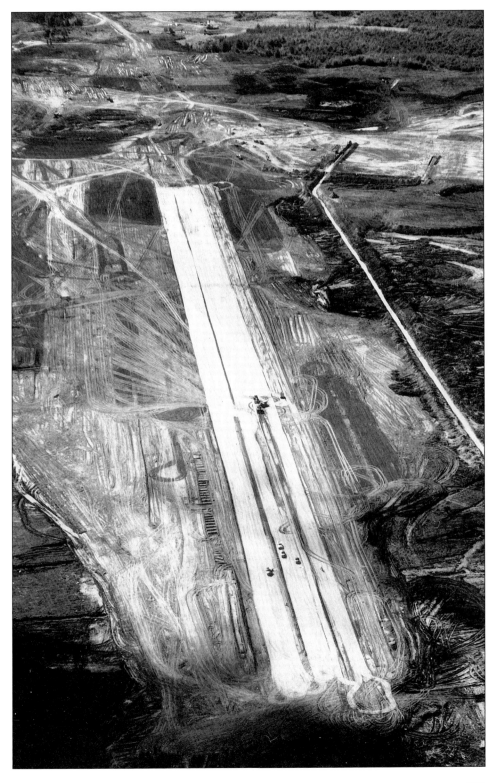

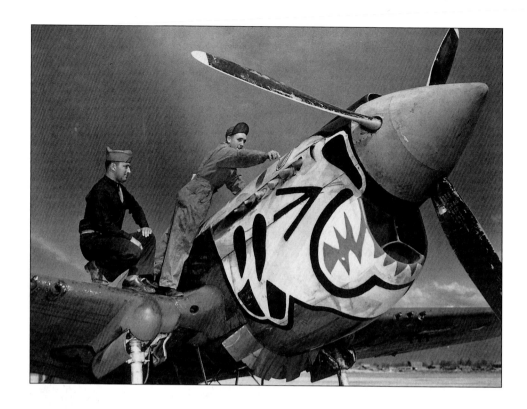

The federal government spent $100 million in the Alaska Territory to make it ready for military activity. Ready for what? Invasion? Military experts generally scoff at the idea that an enemy would attempt to capture a territory so far from home, so sparsely settled and undeveloped that it would be impossible to hold it successfully. Attacking Parachute troops? Air-borne tanks? A siege of Alaska by an enemy fleet? No; none of these. Contrary to popular impression our Army and Navy are not primarily concerned today with Alaskan defense. There is another reason for all the military preparation going on up there in such a hurry right now. That reason is offense.

Corey Ford, Collier's Weekly, November 29, 1941

Above: A P40E, part of the Eleventh Fighter Squadron is given a final check by a mechanic. April 1943.

When America entered the war in 1941, the Eleventh Air Force at Fort Richardson had only 6 medium bombers and 12 pursuit planes. Gov. Ernest Gruening remarked, "A handful of enemy parachutists could capture Alaska overnight."

Opposite: The L Street apartment building was one of the first modern apartment complexes in Anchorage. Here it is under construction in 1951.

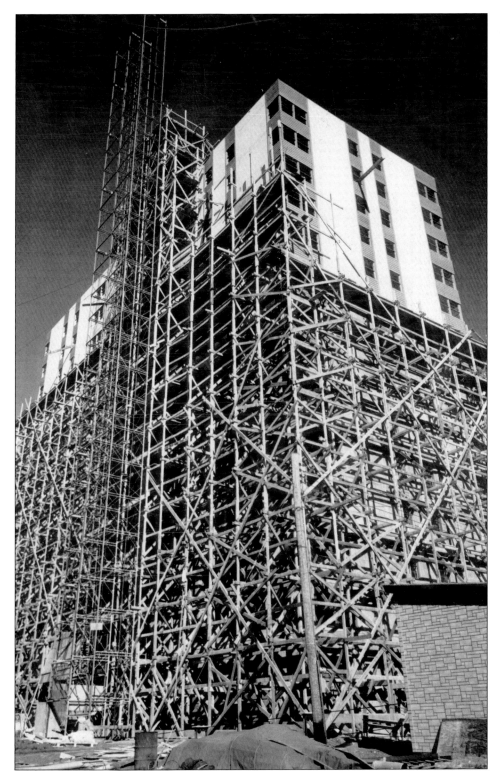

The airplane was changing Alaska rapidly. We'd talked with
my old friend Roald Amundsen, and with Sir Hubert
Wilkins, and they said it was inevitable. Dog drivers shook
their fists at the fragile Jennies and Swallow biplanes, because
they knew their own days were numbered. Already the pilots
had taken most of their passenger business; now they were
carrying furs and even starting to handle the mail.
Klondy Nelson, Daughter of the Gold Rush, 1958

*Above: Soldiers at Fort
Richardson perform calisthenics in
front of their tents during World
War II.*

Above: An army cook at Fort Richardson prepares salmon outside a cook tent during World War II.

The day salmon stop making their way to downtown Ship Creek is the day Anchorage will have lost touch with its roots.

Anchorage Mayor Tony Knowles, at a banquet marking the 25th anniversary of statehood, January 3, 1984.

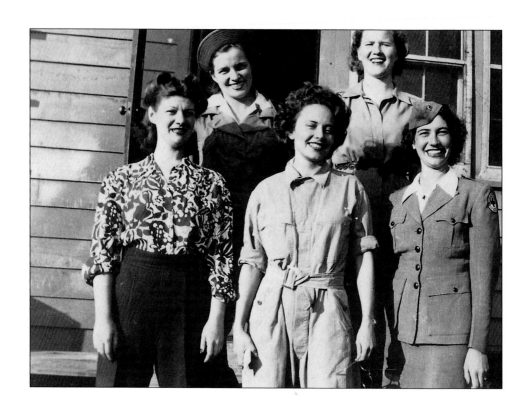

A heavy buildup of Fort Richardson (now Elmendorf Air Force Base) during World War II and continued military investment in the region after the war brought thousands of soldiers, as well as contractors to the government. (This) resulted in a population boom; Anchorage grew from a little more than 4,000 in 1940 to 44,000 in 1960.
Alison Hoagland, Buildings of Alaska, 1993

Above: Soldiers at Anchorage's Fort Richardson were served by female nurses, including Helen Jones, who later served in the Aleutians at Amchitka. Here she poses with some of her friends: back row: Mary Brisky, Ella Adamson; front row from left: Helen Jones, Lorabelle Johnson, Donna Butter. July 1, 1944. Jones was at Fort Richardson from 1943-44.

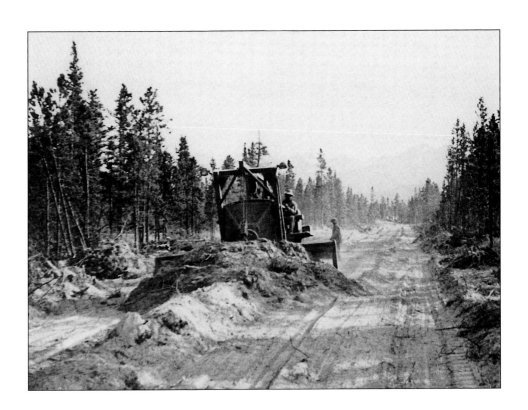

Above: The $150 million Alaska-Canada Military Highway or "Alcan," has been called a major engineering feat of the 20th century. The 1,422-mile road was created in slightly over eight months in 1942. Muskeg, five mountain ranges and more than a hundred streams made construction hellish. Much of the surface was logs laid parallel over a gravel base.

Following his announcement yesterday that the entire Alaska highway is now completed and open to the traffic of motor trucks which started this week to move supplies over the 1,671 miles to Alaska, Secretary of War Henry L. Stimson said today that 10,000 Army officers and men, divided into seven Engineer regiments, and some 2,000 civilians under the Public Roads Administration, completed the job in six months.

Stimson said that pushing at the rate of eight miles a day, they bridged 200 streams, and provided a strip 24 feet wide between ditches.

At one point, the road reaches an altitude of 4,212 feet.
Alaska Daily Empire, October 30, 1942

Opposite Top: A Japanese caricature warns residents and visitors to Fort Richardson that photographs can help the enemy.

Opposite Bottom: Camouflage painting of two-story buildings at Fort Richardson during World War II. Some soldiers lived in Quonset huts on "Government Hill."

Above: USO Church, Fifth and G, winter scene with icicles. February, 1946. Nearly 300,000 military men were stationed in Alaska during the war, and some of them returned to homestead after the war.

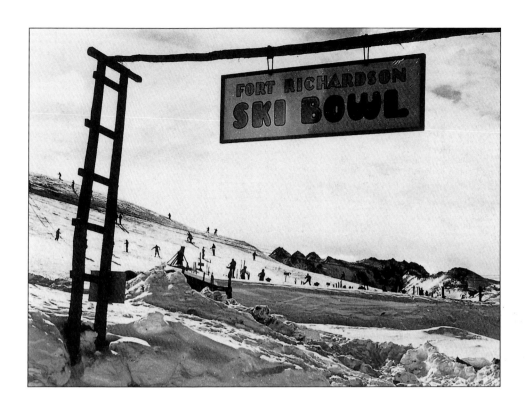

FORT RICHARDSON SKI BOWL

Opposite: Jack Brown, right, one of Ship Creek's earliest white residents, celebrates his 81st birthday on June 9, 1959, by playing golf.

Above: During World War II, the Arctic Valley ski bowl in the Chugach above Fort Richardson offered soldiers recreation during the winter.

Alaska takes justifiable pride in yesterday's announcement by Census Supervisor J.P. Anderson that the population of the Territory as of October 1, 1939, was 71,911 and that the rate of growth in Alaska since the 1930 census has been faster than that of all the States in the Union except two.

Since 1930 the Territory has become the home of 12,633 new Alaskans. Even since the latest census our population has increased greatly. The new figure, large as it is, does not include any of the many people who have come to Alaska in the past year, and we believe the influx since October 1, 1939, has been the greatest in the history of the Territory. Workers on the Army and Navy bases at Anchorage, Fairbanks, Unalaska, Kodiak and Sitka have come north by the thousands, many of them bringing their families. Daily Alaska Empire, November 8, 1940.

Above: The Anchorage Elks Club served as host to United Service Organization gatherings during World War II. General Buckner barred Native women from entering United Service Organization clubs.

Opposite: Early Anchorage residents reunite to share a meal, November, 1954. Left to right: J.D. Whitney, Nellie Brown, John M. "Jack" Brown.

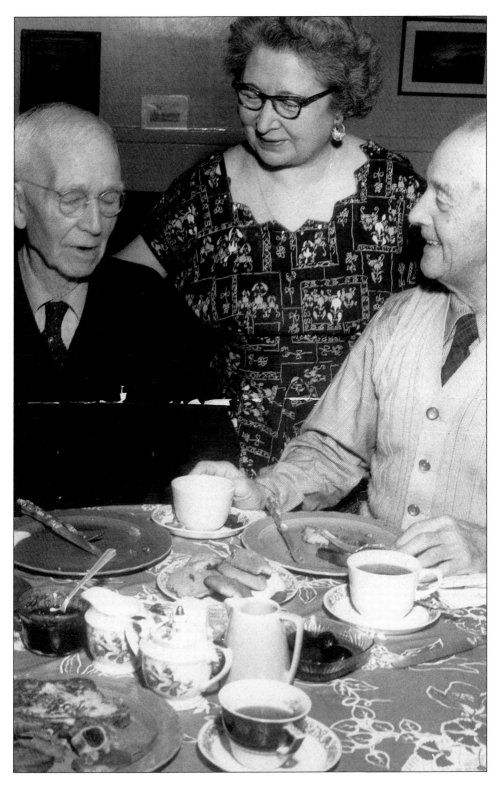

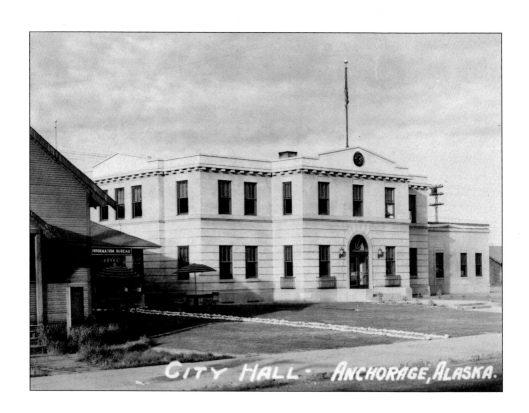

CITY HALL - ANCHORAGE, ALASKA.

District - Anchorage, Alaska

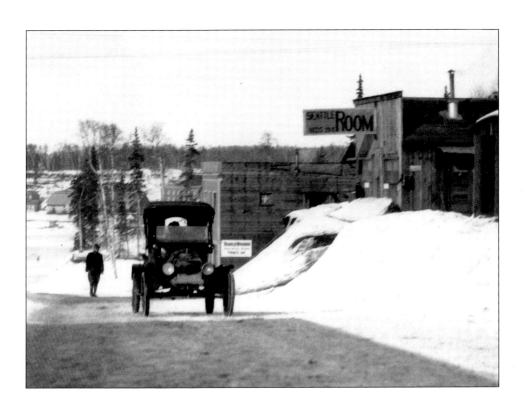

Opposite Top: City Hall, Anchorage. Anchorage's two-story City Hall was the first concrete structure on Fourth Avenue. It was designed by Anchorage architect E. Ellsworth Sedille, and opened in the fall of 1936. "The building is unique for Alaskan construction in the combined use of floor tile, acoustic ceilings, linoleum flooring, steel sash, stenciled ceilings, indirect lighting, birch doors, and fireproof construction," said Henry Wolff, engineer for the Public Works Administration. PWA paid half of the $75,000 cost of the building. City Hall was the center of governmental affairs, housing the Mayor's Office, the Clerk's office, the telephone switchboard, the City Council's chambers, the Police Chief's office, the library, and firemen's quarters.

Opposite Bottom: Residential Anchorage showing some of the original "cottages" built in 1915 on Second and Third Avenues. These cottages were rented to Alaskan Engineering Commission employees.

Above: The corner of Ninth and C Streets in 1916, then considered "way out of town."

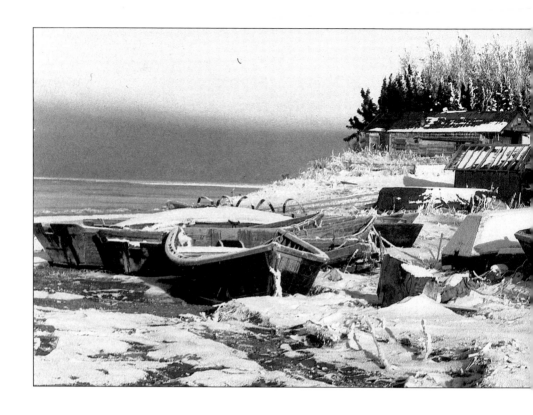

Above: Bootleggers Cove in the 1940s. "Dry laws" were enacted in Alaska in 1918 and not repealed until 1934.

During the early days of Anchorage, when alcohol was banned on Alaskan Engineering Commission property, bootleggers came ashore in this cove, hidden by a bend in the shore from watchful eyes at Ship Creek. Since the 1970s, the area has been known for luxury condominiums and private residences. Access to the dangerous mud flats of the shore is near the railroad tracks and the popular Tony Knowles Coastal Trail.

Opposite Bottom: A typical downtown Anchorage street scene. c. 1950. "Cheechako," the name of a tavern, means "greenhorn" or "newcomer." Its opposite is "sourdough," an experienced resident.

Page 128: J.B. Gottstein, left, in the doorway of his first Anchorage mercantile operation, 1916. Gottstein began importing staples to Anchorage in 1915. The family prospered, with its holdings eventually including Carr-Gottstein Foods and Carr-Gottstein Properties. (In 1999, the statewide Carrs supermarket chain was purchased by Safeway.) Today one of J.B.'s descendants owns the Fourth Avenue Theater.

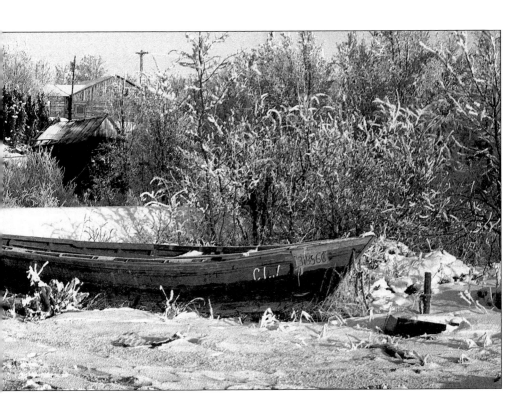

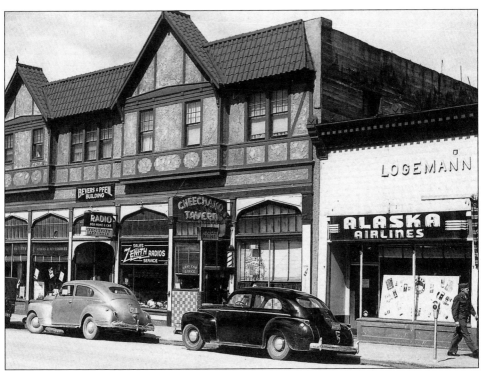

CHRONOLOGY OF SIGNIFICANT DATES IN AND AROUND COOK INLET, ALASKA

15,000 to 30,000 years Before Present: The Bering Land Bridge allows Asians access to Alaska.

9,000 years Before Present: Glacial ice sheets cover most of South central Alaska, including the future site of Anchorage.

8,000 years Before Present: Descendants of the first people to cross Beringia reach Cook Inlet and establish seasonal fishing and hunting camps at sites such as Beluga Point.

1600s: Point Woronzof, near the site of today's Anchorage International Airport, witnesses a battle between Pacific Eskimos and Tanaina Athabascans.

May-June, 1778: On his third and final voyage, British explorer Captain James Cook maps Cook Inlet and trades sea otter pelts with the Tanaina Athabascans.

1791: Russian fur traders Gregory Konovalov and

Amos Balushin found Fort St. Nicholas (Nikolaevsky Redoubt) at the mouth of the Kenai River.

1792: Alexander Baranof sets up a ship-building yard in Resurrection Bay near modern Seward.

1794: Russian priests began to enter Cook Inlet.

1880: Presbyterian missionary Sheldon Jackson calls a meeting to invite representatives of various Protestant denominations to open missions around Alaska. The Methodists selected the Aleutians; the Episcopalians, the Yukon River; and the Baptists, Kodiak Island and Cook Inlet.

1889: After "color" is found in the black sand of Resurrection Creek, the gold rush town of Hope is founded on Turnagain Arm.

July, 1895: Miners in the Six-Mile Creek area found the town of Sun Rise City near Hope.

1900: The government census shows Alaska's population includes 29,500 Eskimos, Indians and Aleuts; 4,300 Caucasians; and 26,000 cheechakos (new arrivals).

1901: The Holy Transfiguration of Our Lord Church is built on a bluff above Ninilchik.

1903: Seward, an ocean port on the Kenai Peninsula, is founded.

1907: The Chugach is formally designated a National Forest.

1909: A roadhouse is built at Moose Pass, north of Seward, to serve miners and road crews.

1911: Two white families (the J.D. "Bud" Whitneys and the Jim St. Clairs) are living at the mouth of Ship Creek.

1912: Alaska is granted Territorial status.

1914-1919: The Iditarod Trail serves as a winter mail route from Seward to Iditarod.

1914: Knik is the largest town and main port of upper Cook Inlet.

1914: President Woodrow Wilson signs a bill authorizing the construction of a federal railroad to connect Alaska's coast and shipping with the Interior. At Seward, 126 miles south of Anchorage, construction begins.

May 22, 1914: Alaska Engineering Commission offices are opened in Seattle. Lt. Frederick Mears is put in charge of Alaska Railroad (ARR) construction.

June 6, 1914: The first field parties (5 men, 20 horses, supplies) arrive at Ship Creek to begin surveying for the ARR. The rails will continue north 358 miles to Fairbanks.

April 10, 1915: Executive Order chooses the Western or Susitna Route for the ARR.

June 5, 1915: The first edition of Anchorage's first newspaper, the *Cook Inlet Pioneer*, is published,

edited by L.F. Shaw. The paper eventually evolves into the *Anchorage Daily Times*.

May-June 1915: Two thousand job seekers pour into the Ship Creek area, seeking work on the railroad. They erect a tent city.

August 17, 1916: First car of coal from the Doherty Mine on Moose Creek in the Matanuska coal fields is shipped to Anchorage.

December 15, 1915: Track reaches Eagle River, a distance of 1325 miles.

November 1, 1916: The first train leaves the new Anchorage passenger depot.

Nov. 17, 1916: A detachment of 40 men, Companies A and C, 14th Infantry, U.S. Army, arrive aboard the steamer *Mariposa*. They are stationed permanently at Anchorage in barracks provided by the AEC.

November,1917: Anchorage's first public school opens—built and donated by AEC. Miss

Oprah Dee Clark is principal. One hundred students enroll on the first day, with four teachers in charge.

1917: A one-room schoolhouse is built in Wasilla.

1918: The first train from Seward steams into Anchorage.

November 23,1920: Anchorage incorporates as a first-class city.

1922: Alaska Natives win the right to vote.

July, 1923: The railroad is completed, linking Seward and Fairbanks.

1923: Sixteen acres between Ninth and Tenth Avenues, known as the "Park Strip," are cleared as a landing strip for planes. This strip was originally Anchorage's firebreak.

1929: The ARR appoints an Agricultural Development Agent and makes a survey of available arable land in the Matanuska and Tanana Valleys. Plans are made to recruit settlers for these areas.

1929: The ARR begins purchasing electricity at 4 cents per kwh from Anchorage Power and Light for use in all buildings in Anchorage.

1930: Merrill Field opens in Anchorage.

1932: Twenty-five prospective homesteaders tour the Matanuska Valley. Ten of them settle on homesteads comprising 1,360 acres.

1935: The Matanuska Colony is founded in an effort to jump-start agriculture in South central Alaska.

October 26, 1937: An explosion at the Evan Jones coal mine at Jonesville kills 14. Special trains are sent from Anchorage carrying doctors and nurses, to bring back the dead and injured.

June 1, 1939: McKinley Park Hotel opens, with a staff of 13. (Mount McKinley National Park is now known as Denali National Park.)

1939: Anchorage area population is 4,000.

July, 1939: Providence, a private hospital, opens, and the practice of admitting private patients to Anchorage's ARR hospital is discontinued.

Summer, 1940: An increase in tourism due to unsettled conditions in Europe causes Anchorage to run out of hotel rooms.

November 20, 1942: The Alaska-Canada Military Highway is opened for military traffic.

March 10, 1943: The first passenger train is run through the Portage Tunnel (4,905 feet) and Whittier Tunnel (14,140 feet).

June 8, 1943: The first passenger ship lands at Whittier, with passengers continuing on to Anchorage by train.

1943: Brig. Gen. Simon Bolivar Buckner, head of the Alaska Defense Command, bans soldiers from patronizing businesses that serve all races, and bars Native Alaskans from USOs. The bans are countermanded by President Franklin Roosevelt.

1946: Anchorage enacts its first zoning ordinance.

1947: Nine families live in the Chugiak-Eagle River area.

December 10, 1951: Anchorage International Airport officially opens.

1957: Oil is discovered on the Kenai Peninsula, south of Anchorage.

June 30, 1958: Congress approves legislation making Alaska the 49th state.

5:36 P.M., March 27, 1964: The most powerful earthquake recorded in North America in the 20th century strikes Anchorage. In Alaska, 4,500 people are left homeless. The earthquake and subsequent tsunamis killed 103 people. The shock registered 9.2 on the revised Richter scale.

1968: Oil is discovered at Prudhoe Bay.

1990: The population of Anchorage reaches 226,000.

Photograph Credits

This book is largely the result of the excellent care and preservation of images up to a hundred years old.

Front Cover, Lu Liston Photo Collection 1687, Anchorage Museum of History and Art (AMHA). Back cover and page 61, AMHA. Title page, Gib Whitehead Collection. Page 4, O.W. Herning. 7, O.W. Herning. 9, Peabody Museum of Archaeology and Ethnology, Harvard University, Cambridge, Mass. No. 41-72-10/50l; from Cook's 1778 voyage. 10, 11, O.W. Herning. 12, top and bottom, H.G. Kaiser, Alaska Engineering Commission (AEC). 12, top, AMHA 1.72.15. 12, bottom AMHA, B75.134.279.13, The Anchorage Times, 1970. 14, Mendenhall, United States Geologic Survey, 1898; AMHA, B91.30.63. 15, top, AMHA, B82.52.249. 15, bottom, O.W. Herning, Leslie Mead collection. 16, top and bottom, AEC. 17, Ann Chandonnet, Tyonek. 18, AMHA, B62.1.9.157. 21, top, engraving, collection of author. 20, bottom, Herning. 23, H.M. Wetherbee; Wetherbee Collection, University of Alaska Fairbanks. 24, Herning, AMHA B67.2.144. 27, top, Herning, AMHA B65.15.7h. 27, bottom, Herning, collection of Leslie Mead. 29, Herning, Mead collection. 30, top, Herning, AMHA, B67.1.124. 30, bottom, Herning. 31, Herning Collection, University of Alaska Fairbanks. 32, 33, Herning, 34, P.S. Hunt photo, AMHA B.94.2.84. 37, top, AMHA B67.17.5. 37, bottom, AMHA B83.146.4. 39, top, AMHA, B78.14.73. 39, bottom, AMHA, Arthur Eide photo, B70.28.161.

40-41, AMHA, B79.1.86. 42, AMHA, B67.17.1. 43, AMHA, Basil Clemons photo, B75.134.135. 44-45, Vol. I, ARR history, AMHA. 46, AMHA, B83.146.92. 47, AMHA, B72.88.22. 48, top AMHA B77.5.5. 48, bottom, Jessie Noble Collection, AMHA, B95.25.42. 49, AEC/ARR Collection, AMHA. 50-51, AEC, H.G. Kaiser, AMHA B61.5.32. 52-53, top, 52-53, bottom, AMHA B.94.2.85. 52-53, top, collection of author. 54, top, AMHA, B80.41.120. 54, bottom, U.S.G.S. album #3, no number assigned, AMHA; collection of Charles C. "Dick" Tousley. 55, Tousley Collection, AMHA B95.25.79. 56, Tousley Collection, AMHA, USGS album #1, AMHA, B98.17.73. 57, Gib Whitehead Collection. 58-59, Gib Whitehead Collection. 60, top, AMHA B.95.13.14. 60, bottom, AMHA B.83.5.42. 61 and back cover, AMHA B77.89.9. 62-63, Kaiser photo, AMHA B.94.2.100. 64-65, AMHA, B83.146.304. 66, AMHA B91.9.155. 69, Lou Liston Collection 2722, AMHA. 71, top, AMHA B.94.2.170. 71, bottom, AMHA, B.94.2.169. 72, Herning. 73, top, Jessie Noble Collection, AMHA B95.25.37. 73, bottom, Herning photo, 1898. 74-75, donated by Mrs. Walter Muller, AMHA B72.88.48. 76, AMHA B.94.2.230. 77; AMHA B91.9.128. Page 78, AMHA B86.4.521. 83, AEC photo, P.S. 84-85, Lu Liston Collection 2774, AMHA. 86-87, Odsather album, AMHA B86.4.83. 88, ARR Vol II, AMHA. 89 top,

AEC G-128, AMHA. 89 bottom, AMHA 80.74.54. 90, ARR history Vol.. II, p. 258; AMHA. 91, Hewitt's Photo, AMHA B92.8.6. 92-93, Cook Inlet Historical Society, AMHA B75.134.106. 94, AMHA B80.194.3. 97, Gib Whitehead Collection. 99, AMHA B90.7.16. 100, AMHA B82.46.51. 101, J.J. Delaney photo. AMHA, B70.19.335. 102-103, AMHA. 104, AMHA, B82.46.61. 105, AMHA B81.108.5. 106, Collection Tom Odale, AMHA B91.9.15. 107, AMHA, B82.66.15. 108, Candy Waugaman Collection, "airplanes" folder, AMHA. 109, Lu Liston 1759-B, AMHA. 110, AMHA B89.23.4. 111, AMHA, B89.23.6. 112, AMHA B88.55.108. 113, Canadian Army Photo, AMHA B62.X.15.1. 114, top, Dorothy Zappa Collection, AMHA B75.104.68. 114 bottom, AMHA B.80.168.22. 115, AMHA B76.82.79. 116, The Anchorage Times. 117, AMHA B94.26.28. 120, top, Nellie Brown Collection, AMHA B88.11.16. 120, bottom, Arthur Eide photo, AMHA 384.47.4. 121, from a postcard donated by Mrs. Walter Muller, AMHA B72.88.9. 122-123 top, AMHA B76.82.79. 123, bottom, AMHA. 128, collection of Robert Gottstein.

About the Author

Writer Ann Chandonnet has lived in Alaska since 1973. She was a feature writer with the *Anchorage Times* for 10 years, and in 1999 became "cops and courts" reporter with the *Juneau Daily Empire*. Her previous books include *Chief Stephen's Parky*, *Alaska's Arts, Crafts & Collectibles*, and *The Alaska Heritage Seafood Cookbook*.

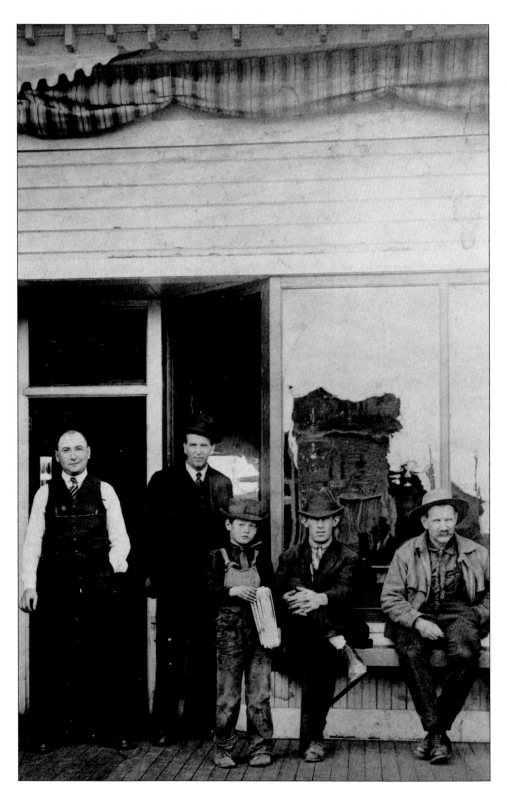